Zen Doodle
DREAMSCAPES
Unlock Your Dreams

Carolyn Scrace

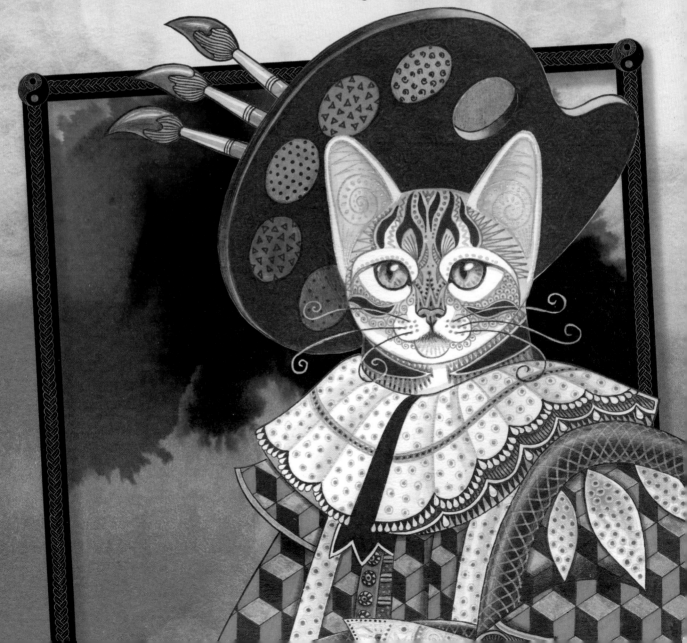

First edition for North America and its
territories published in 2017 by
Barron's Educational Series, Inc.

First published in Great Britain in 2017 by
Book House, an imprint of
The Salariya Book Company Ltd.

© The Salariya Book Company Limited,
MMXVII
25 Marlborough Place, Brighton BN1 1UB

All inquiries should be addressed to:
Barron's Educational Series, Inc.
250 Wireless Boulevard
Hauppauge, NY 11788
www.barronseduc.com

Library of Congress Control Number:
2017930837

ISBN: 978-1-4380-0981-0

Printed in China

9 8 7 6 5 4 3 2 1

BARRON'S

Zen Doodle
DREAMSCAPES
Unlock Your
Dreams

Carolyn Scrace

Contents

6 **Chapter One: The Art of Dreams**

8 Introduction
10 Dream Art
12 Tools and Materials
14 Colorful Dreams
16 Color Theory
18 Dreamcatcher
20 Adding Color
22 Light and Shade
24 Dream Journal

26 **Chapter Two: Flying Dreams**

28 Dreams of Flying
30 Flying Dreams Collage
32 Surreal Images
34 Sponging Technique
36 Mixed Media
38 Flying High

40 **Chapter Three: Dreams and Creativity**

42 Creative Dreams
44 Creative Dreams Collage
46 Imagination
48 Cavalier Cat
50 Richness and Depth
52 Richness and Depth (cont.)
53 In the Frame
54 Gilding the Frame

56 **Chapter Four: Dreams and Emotions**

58 Emotional Dreams
60 Joyful Dreams Collage
62 Happy Thoughts

64 Colorful
66 Flower Power
68 Unicorn

70 Chapter Five: Dreams and Relationships

72 Relationship Dreams
74 Relationship Dreams Collage
76 Yin and Yang
78 Juxtapose
80 Juxtapose (cont.)
81 Night Sky
82 Mystical, Magical

84 Chapter Six: Dreams of Falling

86 Falling Dreams
88 Falling Dreams Collage
90 Topsy Turvy
92 Extreme Perspective
94 Head Over Heels
96 Indenting Technique
98 Weight and Contrast

100 Chapter Seven: Dreams of Chasing

102 Chasing Dreams
104 Chasing Dreams Collage
106 Fantasy Forest
108 Crayon Etching
110 Crayon Etching (cont.)
111 Running Figures
112 On the Edge

114 Chapter Eight: World of Dreams

116 Journey of the Subconscious
118 Color Schemes
120 Building Up
122 Gilded Frame
124 Embellishing
126 Glossary
128 Index

The Art of Dreams

"Why does the eye see a thing more clearly in dreams than the imagination when awake?"

LEONARDO DA VINCI

Introduction

Zen Doodle Dreamscapes is brimming with exciting designs inspired by some of the most common dreams. A variety of simple artistic techniques are explored, including watercolor washes, indenting, and frame printing. This book is designed to encourage creativity and build artistic confidence. It takes the reader through easy-to-follow, step-by-step processes to create incredible, doodled dreamscape artwork.

Fun and Relaxing

Anyone can Zen Doodle. It is tremendous fun and no special tools or equipment are needed. There are no rules to follow—simply let your mind wander, relax, and start doodling!

Doodling repetitive patterns not only produces magnificent artwork, but it also has the effect of creating a sense of inner focus, helping one to engage in the moment and achieve mindfulness. It can develop into a meditative practice that helps quiet the mind and leads to peace and calm.

Dream Analysis

Secret Desires

Dreams enable our conscious and unconscious minds to communicate. They provide us with the opportunity to act out our confusing or painful emotions and experiences while safely asleep. Analyzing your dreams can reveal secret desires and hidden fears, leading to a greater understanding of yourself and your relationships.

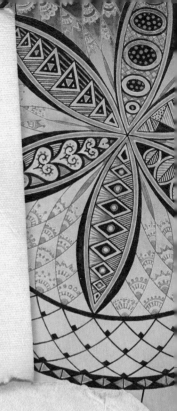

Rapid Eye Movement

Each night we all go through several cycles of sleep, from light to very deep sleep. The phase when we dream the most is called Rapid Eye Movement (REM) sleep. To remember a dream, you must wake up during or just at the end of it in order to write it down and make a sketch (see Dream Journal pages 24–25). It is important to record the prevailing emotions experienced during the dream so you can interpret its meaning.

Universal Symbols

This book includes some dream symbols and their likely meaning. Although many sequences or objects that feature in our dreams have universal symbolism, it is important to take into account how our individual backgrounds and experiences impact on their interpretation and meaning. Dreams are often metaphorical and their meanings may not be what they, at first, appear to be. Some dreams have the opposite meaning. For example, they might explore a hidden aspect of yourself by reflecting it in reverse in your dream.

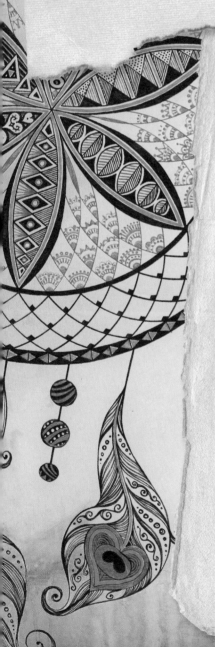

Dream Art

Surrealism

Art inspired by emotional, irrational visions or dreams appears to have developed in European literature toward the end of the 18th century. By the late 19th century, Symbolist and Expressionist artists had begun to use dream imagery to create visual art. It was during this period that Sigmund Freud, neurologist and founder of psychoanalysis, began exploring dreams and the subconscious mind. Freud's work, along with that of the Symbolists and Expressionists, was highly influential to the Surrealist movement that developed in the early 20th century. The Surrealists rejected the rules of society and the limitations of the conscious mind. They believed that the creativity coming from a person's subconscious was more powerful and real than from conscious thought.

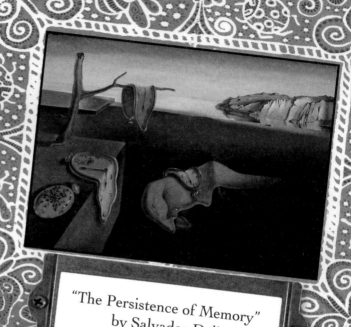

"The Persistence of Memory" by Salvador Dali

Salvador Dali (above) was a Surrealist artist. He described many of his works as "hand-painted dream photographs."

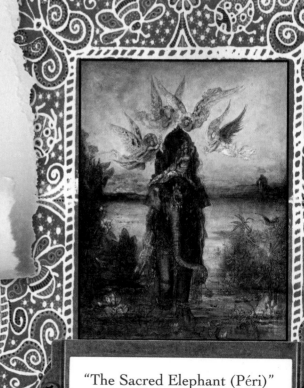

"The Sacred Elephant (Péri)" by Gustave Moreau

Gustave Moreau (right) was a Symbolist painter. He created images that evoked mystery and tension by contrasting the ideal and the divine with physical nature.

Pierre Puvis de Chavannes (right) was a Symbolist painter. His work featured dreams, symbolism, and fantasy rather than naturalism and reality.

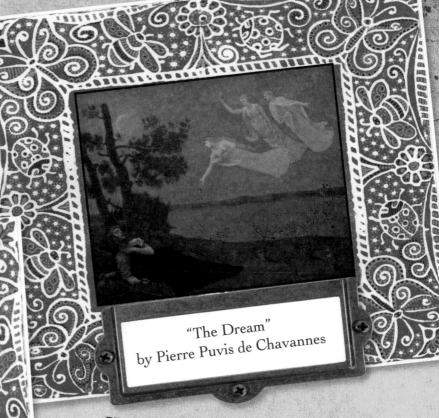

"The Dream" by Pierre Puvis de Chavannes

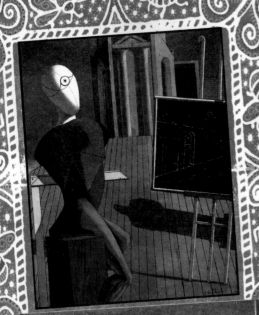

"The Seer" by Giorgio de Chirico

Henri Rousseau (below) was mainly a self-taught artist. His work, a surreal combination of Primitivism and fantasy, had a poetic, dream-like quality.

"The Sleeping Gypsy" by Henri Rousseau

Giorgio de Chirico (above) was the founder of the Metaphysical art movement. His dream-like work featured faceless mannequins and strange combinations of everyday objects.

Pencils

Graphite pencils come in different grades, varying from hard to soft. They produce a wide range of shades, from gray to black.

Pencil Crayons

Pencil crayons are ideal for shading in areas of doodle. Use for blocking in solid colors, or try layering darker colors on top of lighter ones for added depth and richness.

Felt-tip pens come in a wide range of colors, line widths, and styles. Large, rounded nibs are ideal for blocking in areas. Choose small, pointed nibs for detailed work.

Felt-Tip Pens

Tools and Materials

No special tools or materials are required for Zen Doodling. Use whatever you have on hand—a scrap of paper and a pencil are all you need to get started. The most important thing is to relax and enjoy the wonderful adventure that is Zen Doodle.

Pleasurable Experience

These are some of the tools and materials I used to illustrate this book. Experiment with different art materials to find out which ones you most enjoy using.

Watercolor paints come in solid blocks, tubes, or in liquid form. Add water to mix the colors. Use for blocking in areas, adding fine detail, or creating subtle washes.

Watercolors

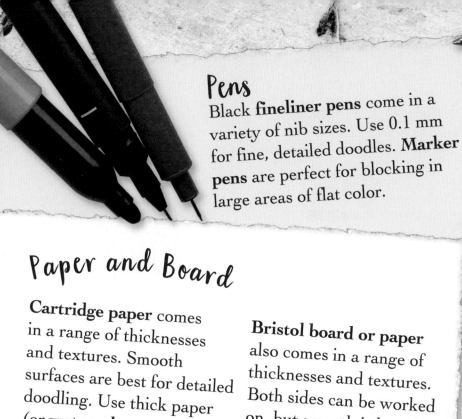

Pens

Black **fineliner pens** come in a variety of nib sizes. Use 0.1 mm for fine, detailed doodles. **Marker pens** are perfect for blocking in large areas of flat color.

Paper and Board

Cartridge paper comes in a range of thicknesses and textures. Smooth surfaces are best for detailed doodling. Use thick paper (or **watercolor paper**) for watercolor washes.

Bristol board or paper also comes in a range of thicknesses and textures. Both sides can be worked on, but smooth is best for detailed work.

Gel Pens

Use **metallic gel pens** for detailed doodles on darker tones. They come in a range of colors including gold, silver, and bronze. **White gel pens** are most effective when used on black or dark colors.

Fineliner pens come in a huge range of colors. Use for coloring delicate patterns or creating detailed doodles. Try layering to create subtle colors and effects.

A small pad or sketchbook is perfect for making notes and quick sketches.

Keep one beside your bed at night so you can record your dreams the moment you wake up

Fineliner Pens

Colorful Dreams

We often associate colors with different moods and emotions in our waking life. Similarly, colors can hold great significance when we analyze our dreams. Colors are subjective and very personal, so only you can unlock their secrets.

Red

On one hand, red may represent love and passion but, on the other hand, it can mean anger and violence, or may warn of danger. Conversely, it can point to a lack of energy and tiredness.

Orange

Orange signifies sociability, friendliness, generosity, and optimism. It represents sensual stimulation, creativity, and the desire to broaden one's horizons.

Yellow

Yellow can have positive or negative associations. During a pleasurable dream, yellow can reflect happiness, hope, and innocence. However, in the context of an unpleasant dream, it can mean cowardice, deceit, indecision, or sickliness.

LOVE Friendship Tiredness OPTIMISM GENEROSITY Cowardice Happiness Jealousy HEALING Hope PROSPERITY

Purple

Purple is associated with royalty, wealth, and spirituality. It implies inspiration and creativity, yet also both passion and calmness. Deep purple may also imply moodiness.

Blue

Blue reflects peace, tranquility, truth, heaven, and eternity. It can also signify optimism or a need to break free. Conversely, it can indicate sadness or depression.

Black

Black is associated with mystery, danger, and death. It can also suggest rejection, loneliness, and depression. However, in the context of a pleasant dream, it can also mean spirituality.

White

White signifies innocence, purity, perfection, peace, love, and new beginnings. It can also symbolize concealment or mourning.

Green

Green represents growth, vitality, hope, and healing. It can also symbolize prosperity or jealousy. Green may suggest progress or a lack of experience.

PEACE Inspiration PASSION Anger Spirituality ETERNITY TRUTH Optimism Depression VITALITY SADNESS Growth

Color Theory

Color Wheel

The color wheel (opposite) is very handy when choosing color schemes for doodle designs, and when blending colors together.

Primary Colors

Red, yellow, and blue are primary colors. They cannot be made by mixing together any other colors. All other colors are derived from these three primary colors.

Secondary Colors

Purple, orange, and green are secondary colors. They are formed by mixing equal amounts of two primary colors. For example, mixing red with yellow produces orange; yellow with blue makes green; and blue with red creates purple.

Tertiary Colors

Red-orange, yellow-orange, yellow-green, blue-green, blue-purple, and red-purple are all tertiary colors. They are formed by mixing equal amounts of a primary and a secondary color.

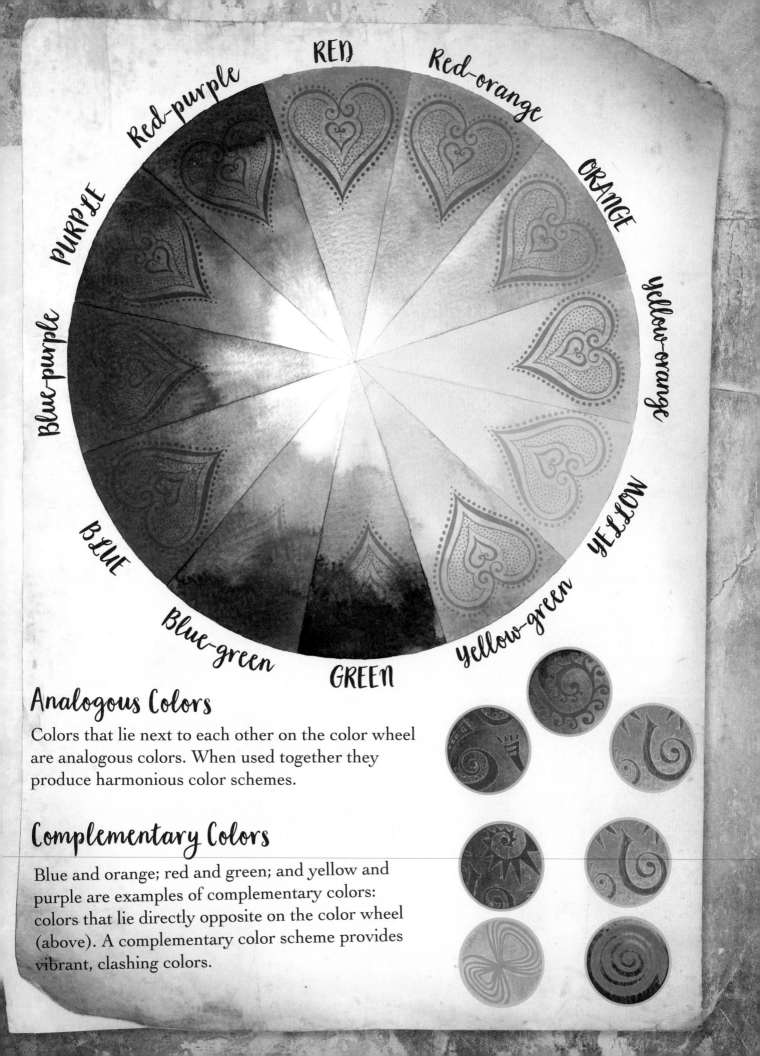

RED

Red-orange

Red-purple

ORANGE

PURPLE

yellow-orange

Blue-purple

YELLOW

BLUE

yellow-green

Blue-green

GREEN

Analogous Colors

Colors that lie next to each other on the color wheel are analogous colors. When used together they produce harmonious color schemes.

Complementary Colors

Blue and orange; red and green; and yellow and purple are examples of complementary colors: colors that lie directly opposite on the color wheel (above). A complementary color scheme provides vibrant, clashing colors.

Dreamcatcher

Protection from Bad Dreams

A dreamcatcher is a willow hoop decorated with beads and feathers with a corded "spider's web" woven inside. Originating from Native American culture, a dreamcatcher's traditional purpose is to encourage good energy and protect against bad dreams.

Thumbnail Sketch

Make a rough sketch of a dreamcatcher design. Add bold leaf shapes in the center to decorate with Zen Doodle patterns.

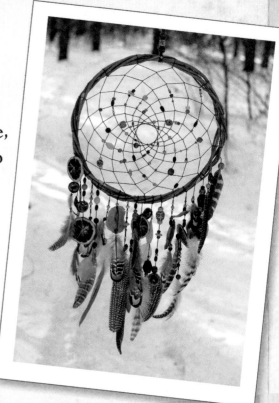

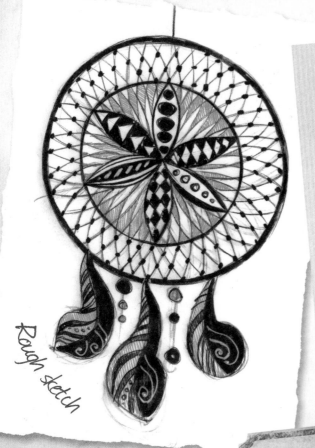

Rough sketch

Zen Doodle Patterns

If you can draw a square, a diamond, and a heart-shape, you can Zen Doodle these three patterns.

Break the patterns down into simple steps. Use a black fineliner pen to draw them in. Add color with a blue fineliner pen and gold gel pens.

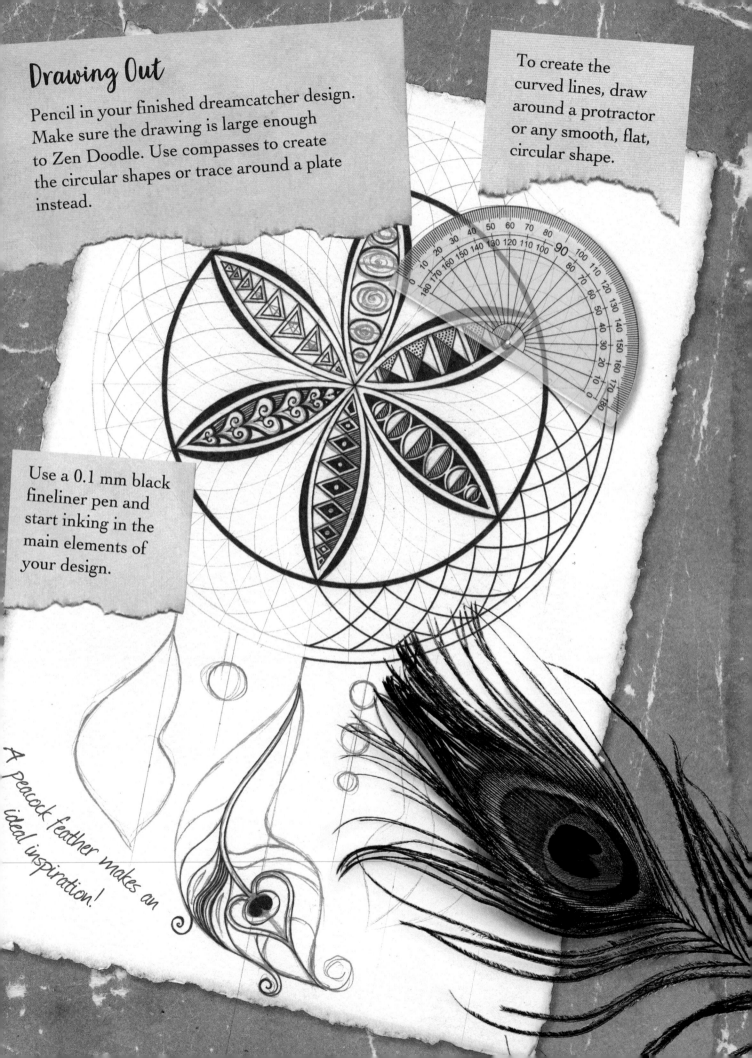

Drawing Out

Pencil in your finished dreamcatcher design. Make sure the drawing is large enough to Zen Doodle. Use compasses to create the circular shapes or trace around a plate instead.

To create the curved lines, draw around a protractor or any smooth, flat, circular shape.

Use a 0.1 mm black fineliner pen and start inking in the main elements of your design.

A peacock feather makes an ideal inspiration!

Adding Color

Color Scheme

Your choice of color scheme can transform your Zen Doodle design. The limited palette of blue and gold with black and white chosen for this dreamcatcher results in a fresh, sophisticated look.

Building Up

Finish Zen Doodling all the black elements. When dry, erase all the pencil lines. Build up the design by using a pale blue fineliner pen to doodle selected areas.

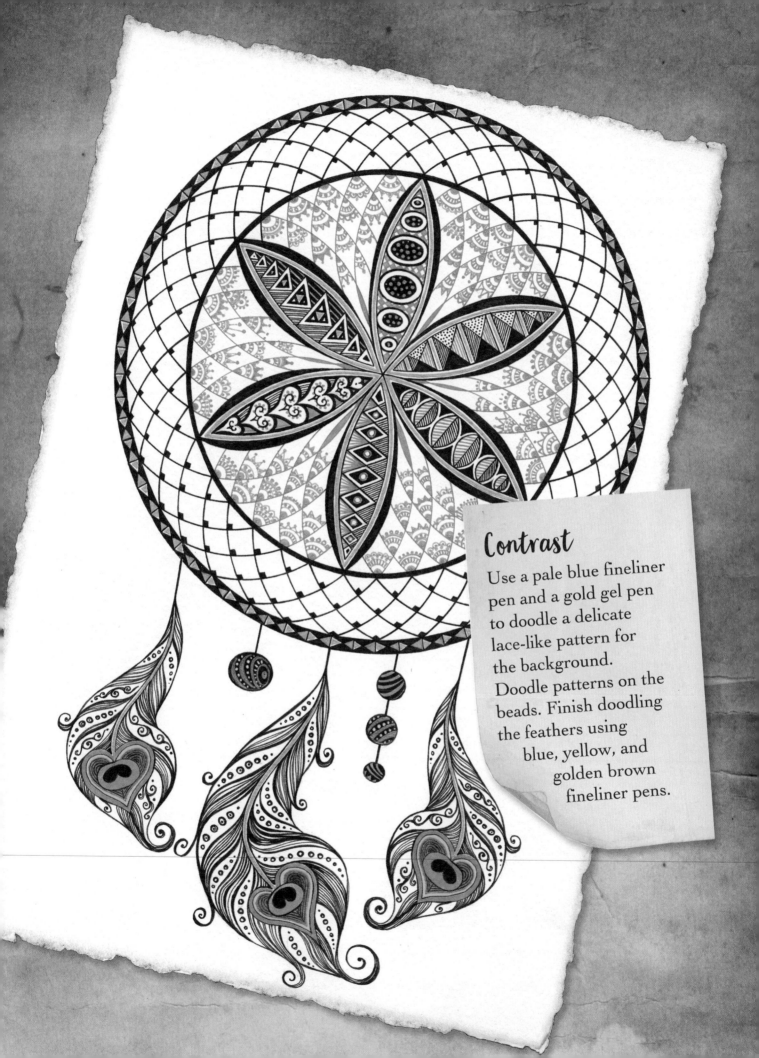

Contrast

Use a pale blue fineliner pen and a gold gel pen to doodle a delicate lace-like pattern for the background. Doodle patterns on the beads. Finish doodling the feathers using blue, yellow, and golden brown fineliner pens.

Light and Shade

Shading Techniques

Shading is a method of adding tone to selected areas of a design to give the appearance of depth and the illusion of three dimensions.

SCRIBBLE WITH A PENCIL

HATCHING WITH A PENCIL

HATCHING WITH A PEN

CROSS-HATCHING WITH A PEN

Hatching uses fine parallel lines; the closer the lines, the darker the tone. This technique is very useful when doodling with a pen, which only produces a solid line.

Cross-hatching uses two or more sets of hatching that criss-cross at angles. Build up the tones by adding more sets of close-knit lines.

Scribble (top) uses a scribbled line to create tone. Both **scribble** and **hatching** (above), with a pencil, produce subtle areas of tone.

Three Dimensions

Draw a simple cube and cylinder. First choose the direction of your light source. Then add shading and transform the drawings into amazing 3D shapes!

LIGHT SOURCE ✳

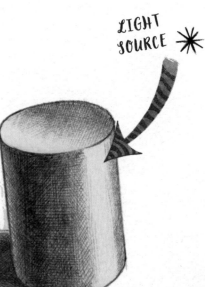

Before...

Flat and Dull

This circular Zen Doodle design would benefit from some shading to give it an interesting 3D effect.

Graduated Shading

I chose my light source, then used a black 0.1 mm fineliner pen and a combination of hatching and cross-hatching to produce graduated shading.

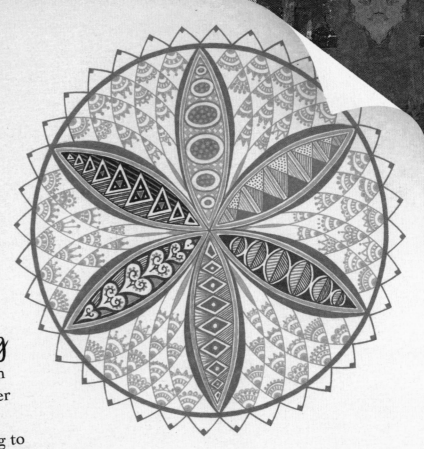

✳ *LIGHT SOURCE*

and After

Depth and Vibrancy

The shading on and around the petal shapes makes them appear rounded and three dimensional. Additional bands of shading on the background gives the design further depth and vibrancy.

Dream Journal

Recalling Dreams

Keeping a dream journal is an intrinsic part of *Zen Doodle Dreamscapes*. If, like many people, you wake during the night unable to recall your dream, using a journal is an easy way to train your dream memory. Place it by your bed so it is clearly visible. Focus on the journal before going to sleep, and when you wake during the night and again in the morning, keep telling yourself to "remember your dreams."

'The Creative Cat'

Dream Collection

Every night we each dream for about 100 minutes. Try to record your dreams whenever possible. I sometimes miss a few nights, then for several nights I can record two or more vivid dream sequences. I treasure my dream journals and when they are full I decorate the covers and use them as a reference to look at my dream history.

How to Keep a Dream Journal

 Get a notebook or sketchpad to use as your journal. Place it within arm's reach of your bed, along with a pen or pencil.

 As soon as you wake up, make a sketch or sketches of the most powerful images from your dream.

 Jot down anything else you recall; using the present tense can focus your mind on the moment.

 Record the overriding emotion of the dream and any major themes.

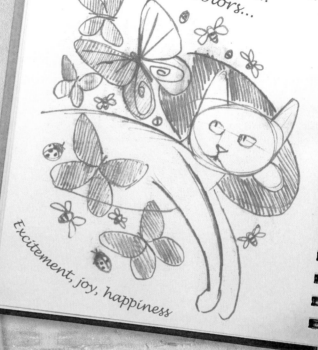

February 12th
Cat surrounded by butterflies...
bees buzzing, ladybugs...
artist's palette, colors...

Excitement, joy, happiness

"FLIGHT OF FANCY..."

Pencil-shaped legs and feet

In the Morning...

 In the morning add the date, and note any particular concerns or events that are affecting your waking life. This could be helpful when interpreting your dream.

 If the dream "stays with you," make a more detailed color sketch of your lasting impressions before the memory fades.

 Giving the dream a title can also reveal its hidden meaning.

Flying Dreams

"Flying without feathers is not easy; my wings have no feathers."

TITUS MACCIUS PLAUTUS

Dreams of Flying

Freedom and Euphoria

Dreaming of flying is relatively common. Such dreams can be vivid and exciting and may hold great significance. If, in your dream, you are enjoying the exhilaration of flying, it may suggest you are in control of your life and emotions. The euphoric feeling and sense of freedom may signify that you have released yourself from an overriding problem.

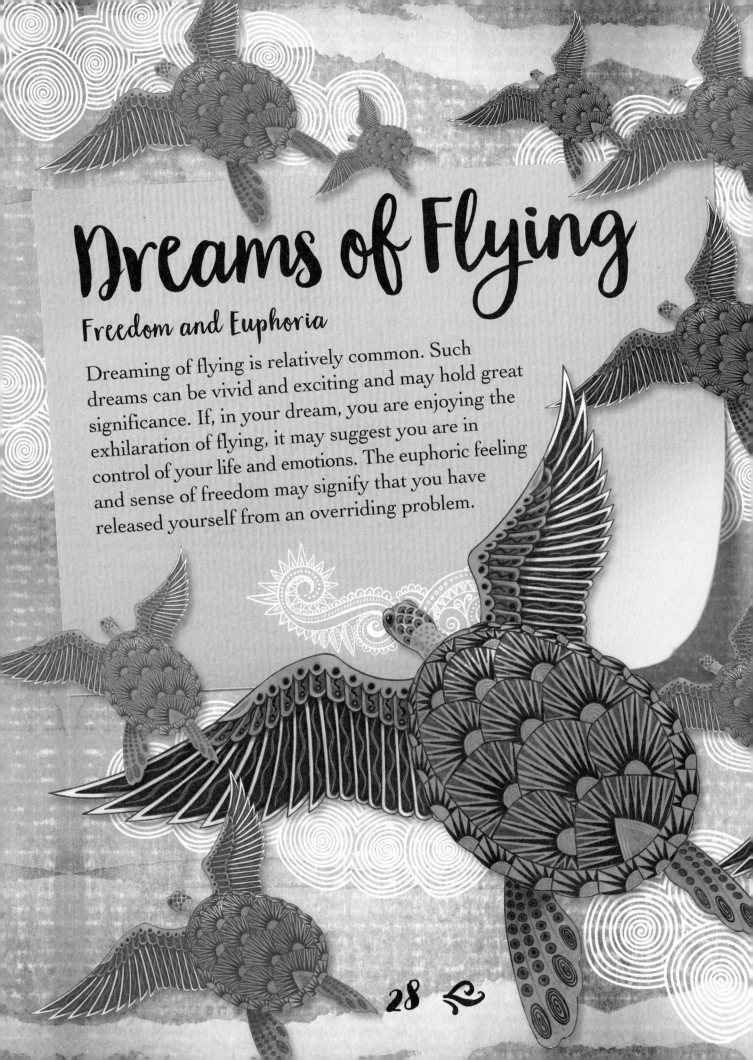

"In my dream I was a butterfly flitting around the sky. Then I awoke. Now I do not know whether I was then a man who dreamt of being a butterfly or am I now a butterfly dreaming that I am a man."

ZHUANGZI

Flying Dreams
Collage

31

Surreal Images

Flying Turtle

Many of my most exhilarating and exciting experiences come from scuba diving. As a result, my dreams are frequently full of images of the undersea world. Recently, I had a particularly surreal dream in which I became a winged turtle flying high above an incredible landscape.

Dream Journal

I refer to my dream journal, where I had jotted down my dream notes and also made some very rough sketches. This was my starting point!

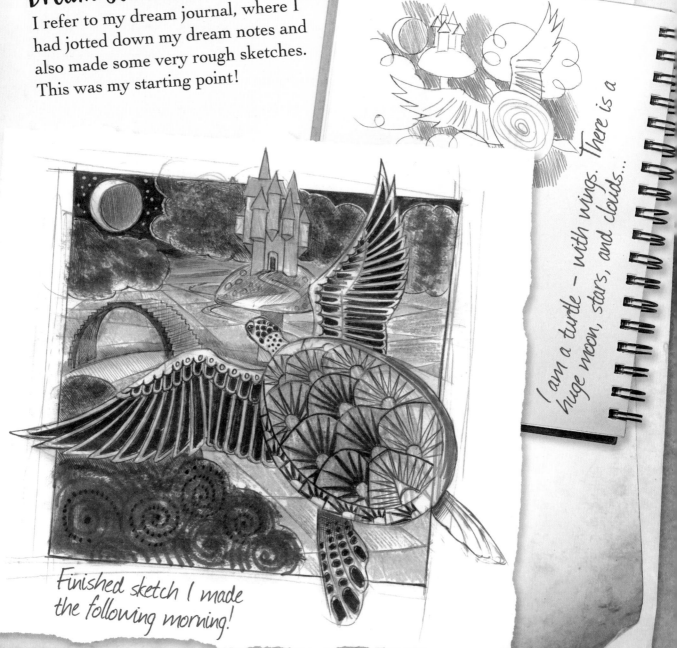

April 24th

I am a turtle – with wings. There is a huge moon, stars, and clouds...

Finished sketch I made the following morning!

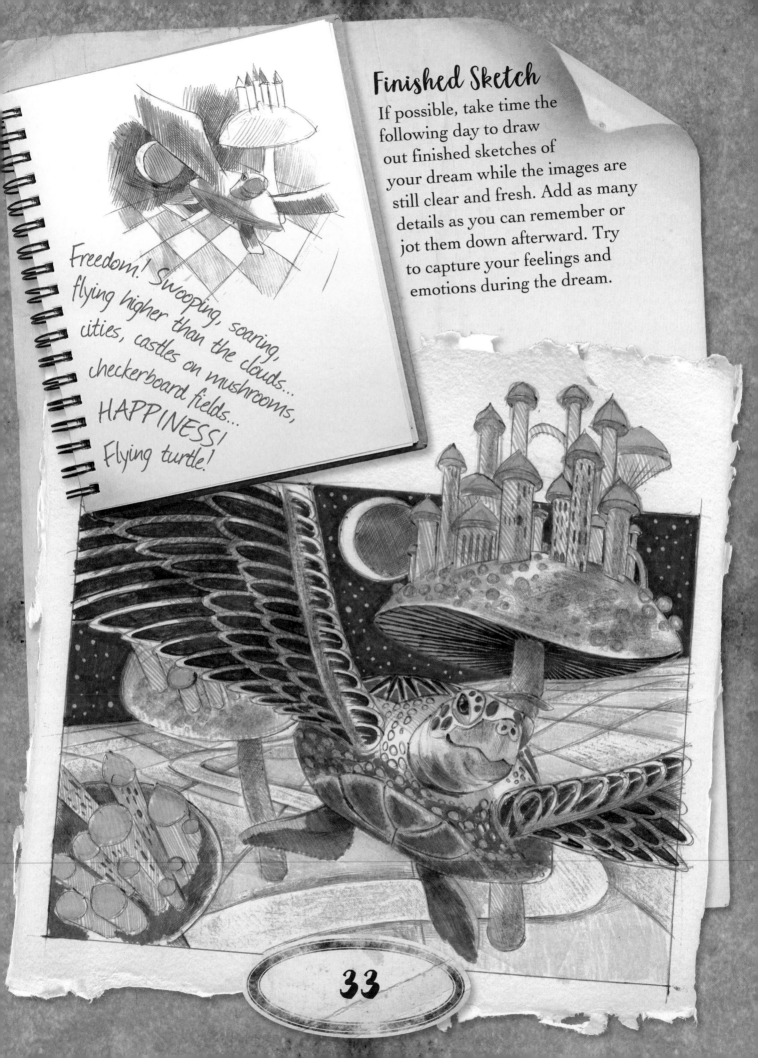

Finished Sketch

If possible, take time the following day to draw out finished sketches of your dream while the images are still clear and fresh. Add as many details as you can remember or jot them down afterward. Try to capture your feelings and emotions during the dream.

Freedom! Swooping, soaring, flying higher than the clouds... cities, castles on mushrooms, checkerboard fields... HAPPINESS! Flying turtle!

Sponging Technique

You Will Need:

- Thick, smooth cartridge or watercolor paper
- Art masking fluid
- Clean sponge
- Watercolor paints or inks
- Clean dish or bowl
- Old paint brush

Dramatic Clouds

The sponging technique is good fun and an easy way to create exciting paint effects. It's an ideal method for painting dramatic clouds. Experiment with different types of sponges, such as a sea sponge, household sponge, or bath sponge, to see what textures they produce.

Artist's tip: Always work to a size you feel comfortable with. However, for this particular technique, working on a larger scale is definitely best.

1 Make a sketch of your final composition. Trace the background design onto thick paper (leaving out the turtle). Ink in the main shapes.

2 Paint masking fluid over detailed parts you want to protect from the cloud effect. Let stand until the masking fluid is completely dry.

3 Using a clean sponge, dab diluted watercolor paints or inks to create clouds. Use paler tones first, then add darker ones. Let the colors bleed.

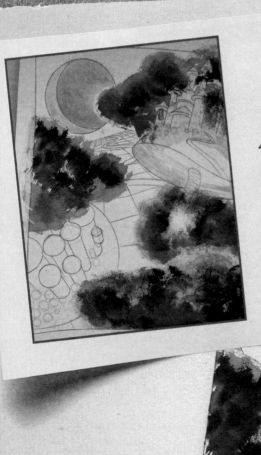

4 Use the sponge to dab more clouds in the foreground. Allow this to dry. Using a clean piece of sponge, dab pale shades of yellow inside the crescent moon circle.

Color the underside of the mushroom dark brown.

Coloring in Background Clouds

Color in the rest of the background. Use watercolor washes, colored crayons, or whatever you prefer. As you work, keep in mind that the moon is the light source. Try to replicate the colors in your dream.

When the paint is dry, rub off the art masking fluid with your fingertips.

Mixed Media

Zen Doodle

Relax and have fun Zen Doodling your design. I built up colors and tones by layering a mixture of different media. Experiment to find which combinations work best for you.

Use a black fineliner pen to doodle the mushroom's stalk and underside.

Layering

Layering red fineliner pen or red ballpoint doodles on top of yellow produces rich, vibrant reds. Use yellow ochre pencil crayon shading with brown ballpoint pen hatching to add shadows to the castle towers.

Dream Meanings

Dreaming of a **fairy tale castle** can indicate that you have unrealistically high expectations of yourself. Instead of trying to achieve your goals, you may be waiting for the fairy tale to happen.

36

Moon's Face

Use a golden brown felt-tip pen and pencil crayons to draw the moon's face. Add shading. Outline the features in gold gel pen, then add Zen Doodle patterns. Use a silver gel pen to doodle spiral "stars."

Use gold and silver gel pens to doodle the patchwork fields.

Curved Border

Add brown pencil crayon shading around the base of the castle towers to give the mushroom tops a 3D look. Finish off the artwork with a curving border drawn in a black fineliner pen.

Dream Meanings

Mushrooms have many powerful symbolic meanings. Dreaming about mushrooms growing in a fantasy world may indicate a desire to escape. It could also mean that you feel out of control or perhaps want the impossible.

Flying High

Sea Turtle Doodles

1 Trace the turtle design out onto a sheet of thick cartridge or watercolor paper.

2 Use a golden brown watercolor wash for the body, head, hind flippers, and the front wing feathers.

3 Use a 0.2 mm black fineliner pen to doodle the outlines of the feathers. Block in solid areas of black with a 0.8 mm fineliner pen or a black felt-tip pen.

4 Zen Doodle the turtle's shell using a 0.2 mm black fineliner pen.

5 Finish doodling the turtle with a brown fineliner pen and a gold gel pen. When completely dry, carefully cut out the turtle shape.

Dream Meanings

In dreams, **turtles** can symbolize many things, including good luck and a healthy and long life. A **sea turtle** particularly signifies single-mindedness and the desire to get one's own way.

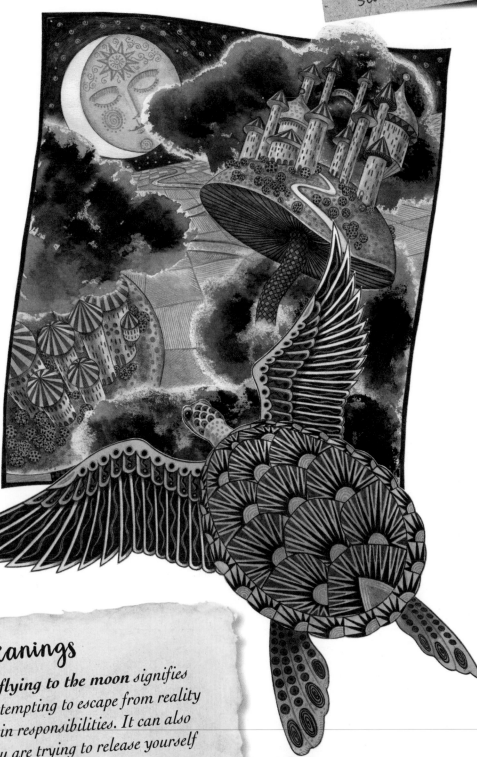

Use double-sided tape to stick the turtle in place.

Dream Meanings

Dreaming of **flying to the moon** signifies that you are attempting to escape from reality or from certain responsibilities. It can also mean that you are trying to release yourself from any limitations.

Dreams and Creativity

"All men whilst they are awake are in one common world: but each of them, when he is asleep, is in a world of their own."

PLUTARCH

Creative Dreams

Dreams are a reflection of our creative energies and, as such, can be very helpful. If you have been engrossed in a particular project or task, it is likely that your dreams will relate to any emotions surrounding the problem and may reflect various creative ideas or solutions. Dreams are a very rich source of creative inspiration, not just for their extraordinarily vivid imagery, but also for the breadth of scope and depth of feeling they evoke.

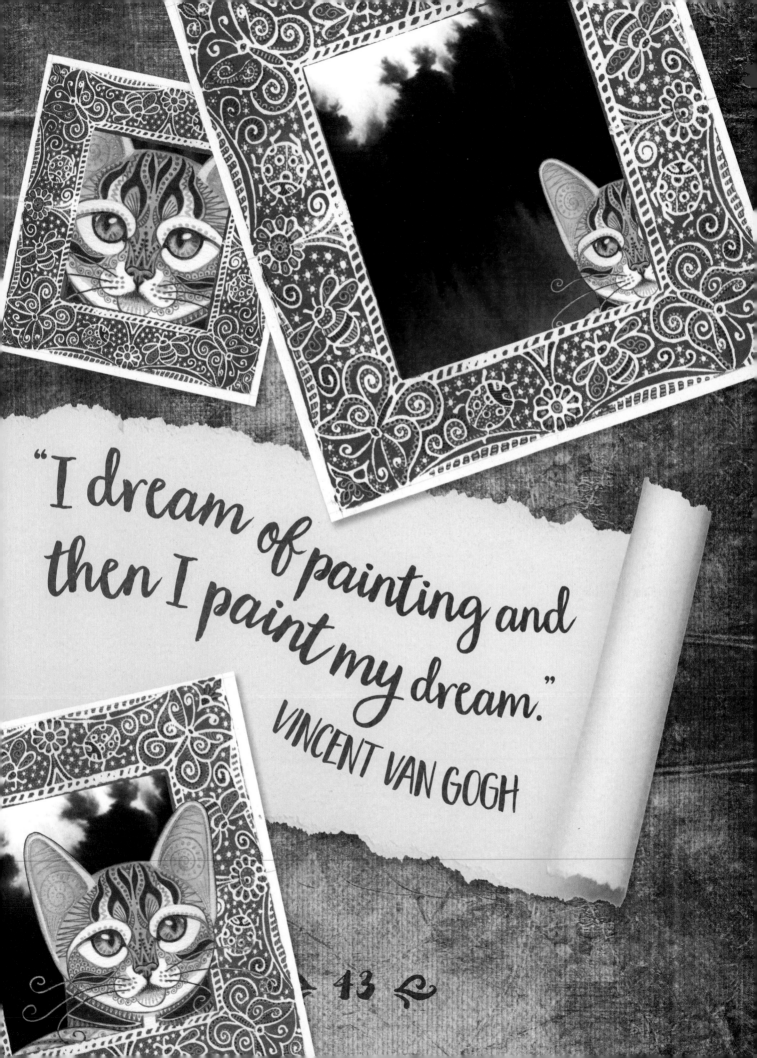

"I dream of painting and then I paint my dream."

VINCENT VAN GOGH

43

Creative Dreams Collage

44

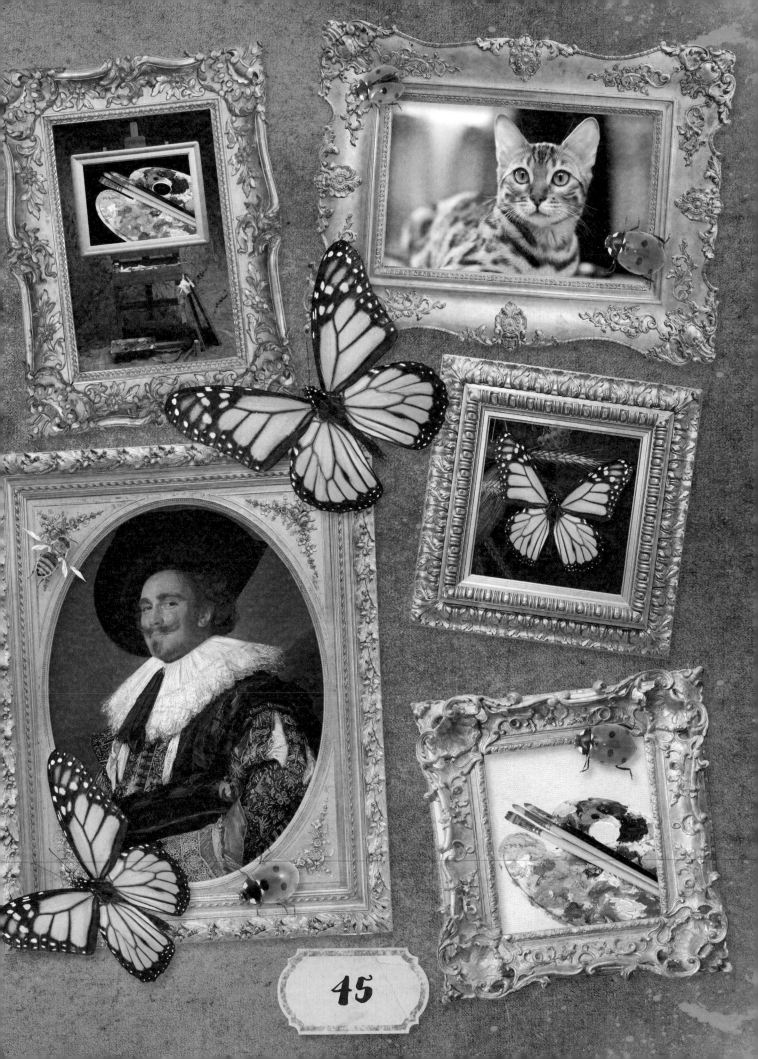

45

Imagination

Creative Solution

The other day, I had been unable to think of a creative solution to a pressing problem. Then I had two vivid dreams that featured a beautiful cat. In the morning, not only had I resolved my problem, but I was able to use the latest sketches in my dream journal as the basis for two finished color roughs.

Cat surrounded by butterflies... bees buzzing, ladybugs... artist's palette, colors...

If a dream is full of seemingly random images, try combining them in different ways. In this instance, I used the cat as the central theme, then "dressed" it in an artist's palette hat, a ladybug necklace, and a butterfly dress!

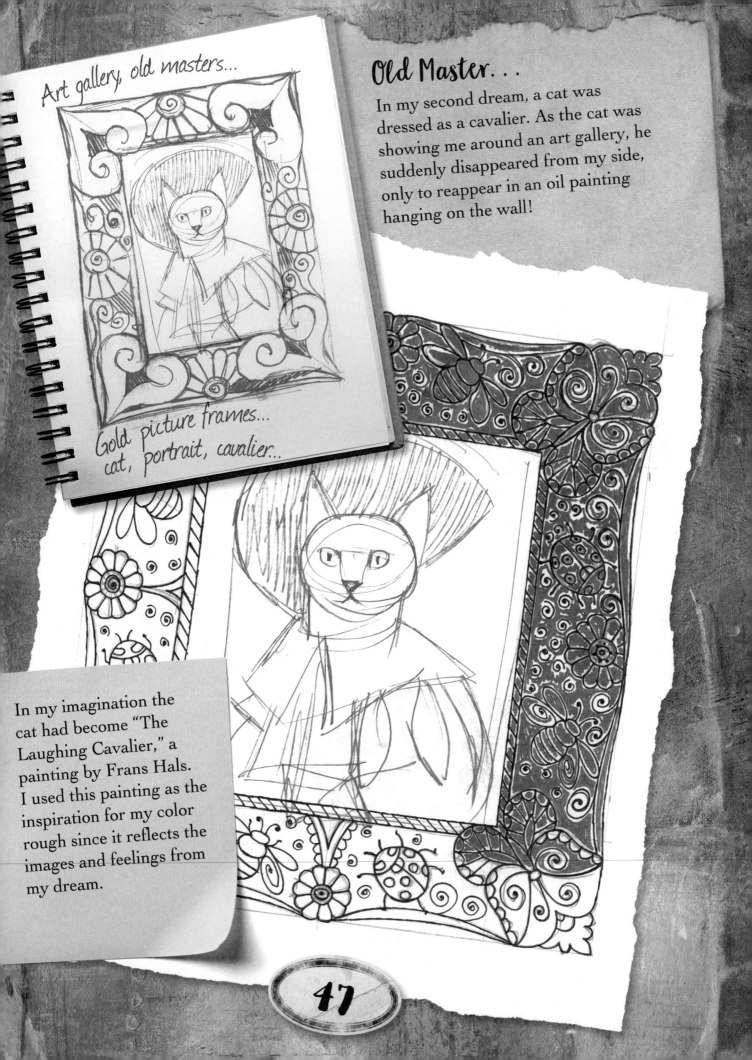

Art gallery, old masters...

Gold picture frames...
cat, portrait, cavalier...

Old Master...

In my second dream, a cat was dressed as a cavalier. As the cat was showing me around an art gallery, he suddenly disappeared from my side, only to reappear in an oil painting hanging on the wall!

In my imagination the cat had become "The Laughing Cavalier," a painting by Frans Hals. I used this painting as the inspiration for my color rough since it reflects the images and feelings from my dream.

Cavalier Cat

Doodle Design

If you make more than one color rough, choose the one you feel is the most powerful. Re-draw the design to the size you intend to work. Bear in mind that if you are going to add a doodled frame, the finished artwork will be proportionately larger.

Experiment

Draw out a finished rough. Block in the main areas of black and gray. This is the perfect opportunity to experiment with different Zen Doodle designs.

Artist's tip: To check the tonal contrast, half close your eyes and look at the drawing from a slight distance. This makes it easier to see which areas are light, half tone, or shadow.

3D Pattern Deconstruction

If a pattern looks too difficult to doodle. . . then study it! By breaking down or deconstructing the pattern into simple steps, it will become surprisingly easy to draw.

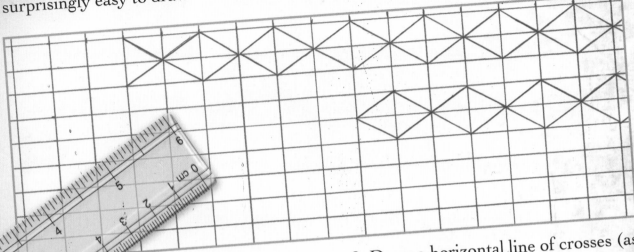

1 Start by penciling in a rectangular grid. Place a ruler on the grid so it passes through diagonal corners: if necessary, adjust the proportions of the grid.

2 Draw a horizontal line of crosses (as shown) through two lines of the grid. Leave a one line gap. Repeat to draw the next line of crosses, but stagger the pattern (as shown).

Light source ✳

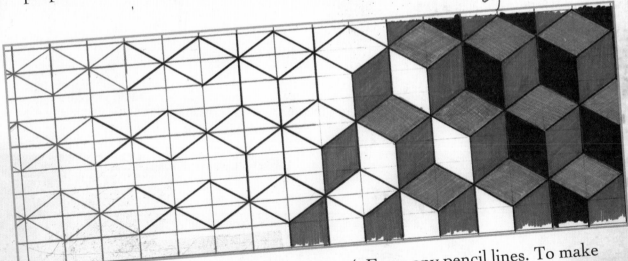

3 Draw a third line of crosses in the same position as the first to create a staggered pattern of diamond shapes. Ink in the pencil crosses with a black fineliner pen. Now draw a series of vertical lines between the rows of horizontal diamond shapes.

4 Erase any pencil lines. To make the pattern appear 3D, first choose your light source. Color in the lightest part (in this case the top) with a pale tone. Color in the darkest part with black and use a midtone to color in the remaining shapes.

Richness and Depth

Continue to Modify...

Don't feel constrained by the finished rough – you can continue to modify it as you work. An exciting part of the creative process is seeing the design evolve and develop. In this instance, I combined the image of the cat's palette "hat" which featured in my first rough with my design of choice: the cat dressed as a cavalier.

Dream Meanings

A dream featuring a **cat** may symbolize creativity, power, and femininity. Conversely, it can also warn of bad luck, misfortune, and danger! However, dreaming about a cat in an artistic setting could be a metaphor for the release of your creative spirit.

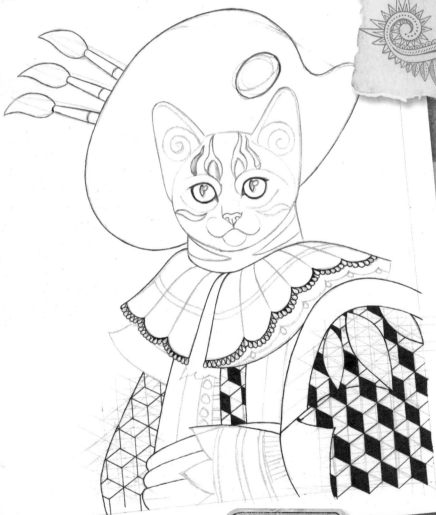

Trace out your final design. Use a 0.1 mm or a 0.2 mm black fineliner pen to ink in the main outlines.

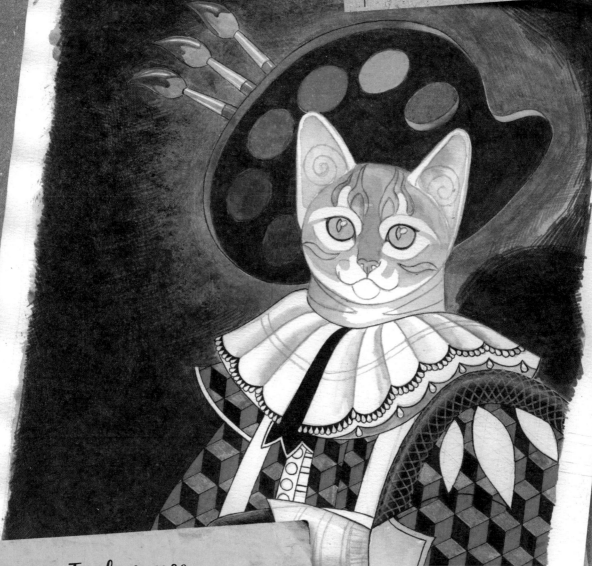

Combining Techniques

Try combining several different techniques
to build up the deep, rich brown of the
background. Start by painting a light brown
watercolor wash. Once dry, build up darker
tones by using cross-hatching in different
shades of brown felt-tip pens. Leave a pale
area around the palette "hat." To create
texture and blend in the tones, apply dark
brown watercolor using the sponging
technique (pages 34–35). Block in the main
areas of color.

Paint the cat's head and the
neck ruffle with pale watercolor
washes. Layer felt-tip hatching
over the top of the watercolor
paint to create the rich tones of
the cat's palette "hat."

Richness and Depth (cont.)

Relax and Doodle

Now relax! Picture in your mind the magic of your dream as you start to Zen Doodle your artwork. Take your time and enjoy the process of drawing doodle patterns.

Artist's tip: Rest your drawing hand on some scrap paper to prevent any smudging.

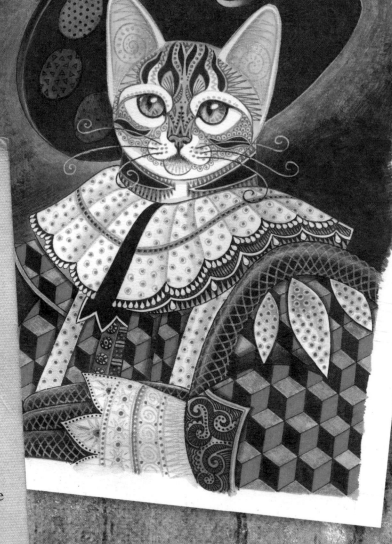

Lace Effect

Use black, light brown, and gold fineliner pens to Zen Doodle the markings on the cat's face. To create the lace effect on the ruffle, cuff, and sleeve, doodle simple patterns in pale gray felt-tip and silver gel pens. Use a gold gel pen to doodle a lattice pattern on the cummerbund and add a lattice pattern to the top of the sleeve. Doodle the cat's palette "hat." Last, use white and silver gel pens with a black fineliner pen to draw in the cat's curly whiskers.

In the Frame

Relief Printing

Relief printing using a polystyrene printing block is fun and one of the easiest forms of frame printing. Create a simple printing block by indenting a sheet of polystyrene with your design. Ink the block, then press it onto a sheet of paper to create a fabulous print.

Printed Picture Frame

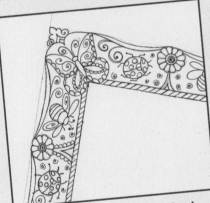

1 Draw your frame design. Use a soft pencil to scribble over the reverse side.

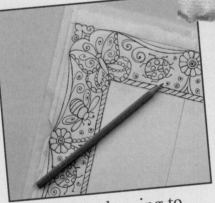

2 Tape the drawing to a polystyrene block, and lightly trace over the lines.

3 Remove the drawing. Use a dry ballpoint pen to indent the design.

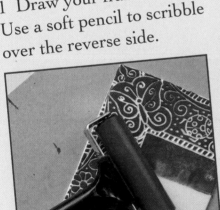

4 Apply ink to the printing block with a brayer roller and place the block face down onto a sheet of paper.

5 Turn the block and paper over. Use the back of a spoon to press the paper down on the printing block.

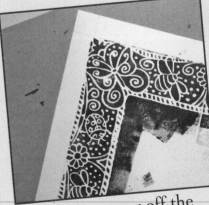

6 Peel the paper off the printing block. The print will be a reverse image of your original design.

Gilding the Frame

Finishing Touches

Leave the print to dry (some printing inks may need to dry overnight). To replicate the appearance of a gilt frame, I used a rich, dark brown printing ink so that I could doodle on top with a gold gel pen.

I found Zen Doodling the uneven quality of the print artistically liberating. Free your mind as you doodle, use simple, bold patterns and enjoy the experience.

Dream Meanings

A **butterfly** symbolizes freedom and happiness. Just as a butterfly's lifecycle involves the process of metamorphosis, dreaming of one may suggest that you are going through a personal transformation and a period of considerable creativity.

Dream Meanings

Bees symbolize diligence, harmony, euphoria, good fortune, and creativity. To dream of bees could imply that all your hard work will leave you "buzzing" with creativity and "busy as a bee" working on exciting new projects.

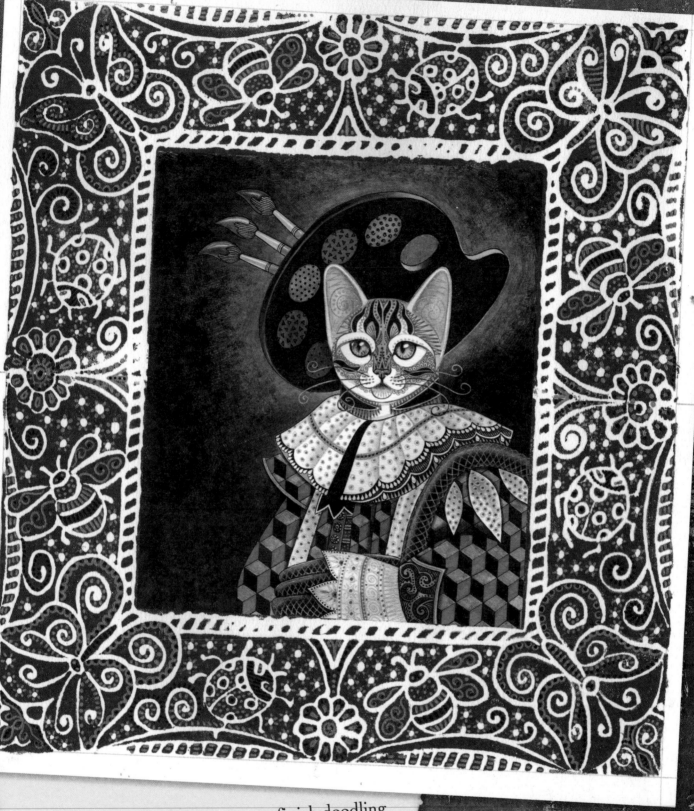

Use a 0.8 mm black fineliner pen to finish doodling the frame. Carefully cut out the cat artwork, then use either double-sided tape or adhesive spray to mount your image inside the frame.

Dreams and Emotions

"Dreams are true while they last and do we not live in dreams?"

ALFRED LORD TENNYSON

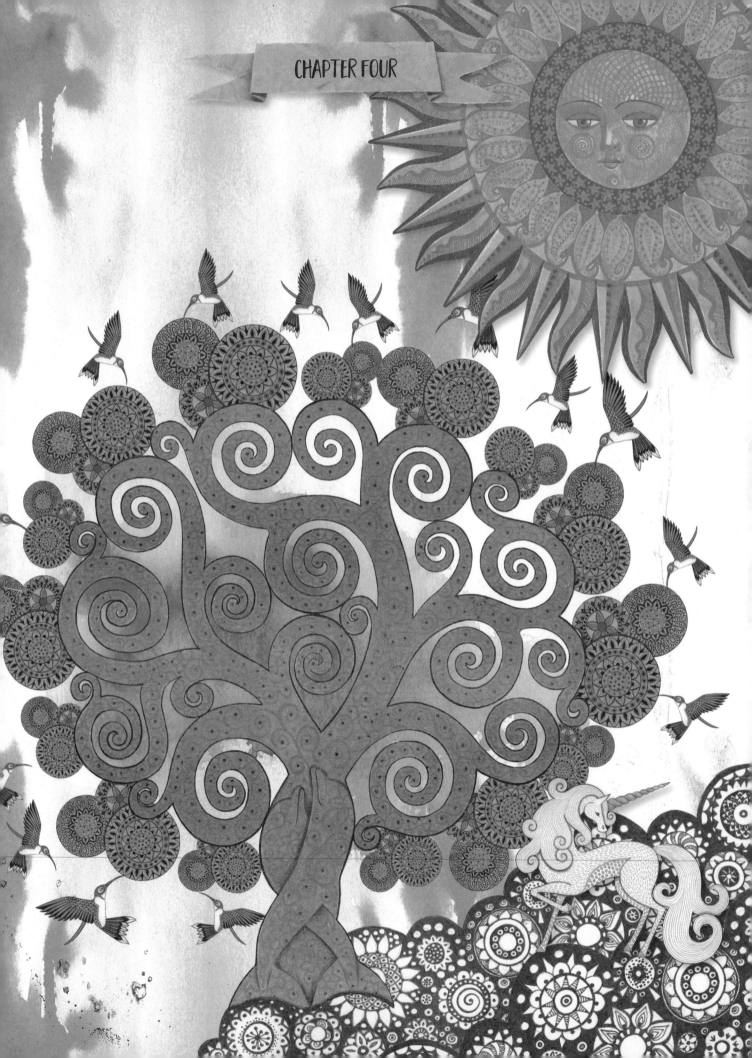

CHAPTER FOUR

Emotional Dreams

Reflection of Innermost Feelings

Dreams capture our changing emotions, and are a reflection of our innermost feelings. Emotions that may have been suppressed during the day can be liberated in dreams, helping you to cope with difficult feelings.

"All that we see or seem is but a dream within a dream."

EDGAR ALLEN POE

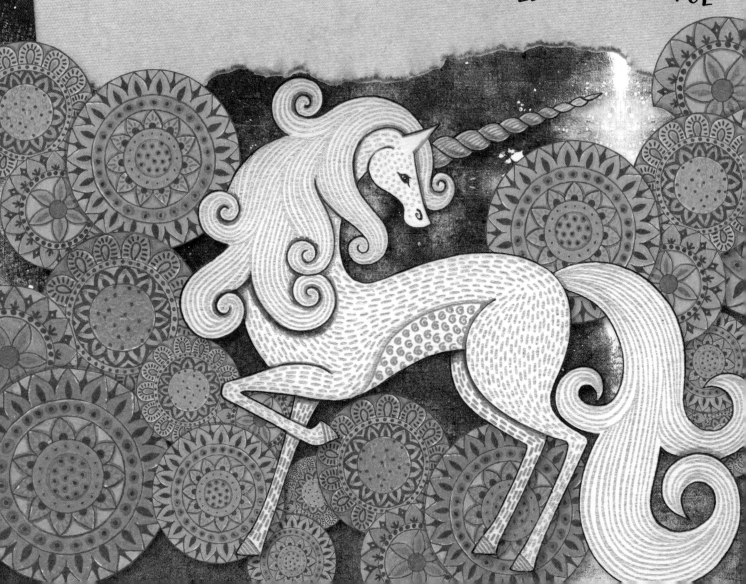

Emotional Dream Meanings

Dreaming that you feel **afraid** or fearful denotes lack of confidence and a sense of inadequacy. It may indicate that you are feeling out of control.

A dream featuring feelings of **anger** can provide a safe outlet to express the emotion you may be experiencing in your waking life.

To dream that you are feeling **anxious** in a situation reflects feelings of apprehension about your daily life. It may indicate that you have suppressed emotions that need to be addressed.

Dreaming of being **embarrassed** denotes lack of self-confidence and hidden insecurity.

Feeling **happy** in a dream can reflect happiness in your daily life. On the other hand, it may be the subconscious mind attempting to counterbalance your inner sadness and tension.

A dream in which you feel **joy** denotes love and affinity with family and friends, and reflects your inner radiance.

Dreaming of **love** or being in love implies that you feel these emotions in your daily life. Conversely, it may imply a desire for closeness and acceptance.

A dream in which you feel **sad** signifies that you feel unhappy and downhearted while awake. The dream may encourage you to think positively, move forward in your life, and become joyful.

Joyful Dreams Collage

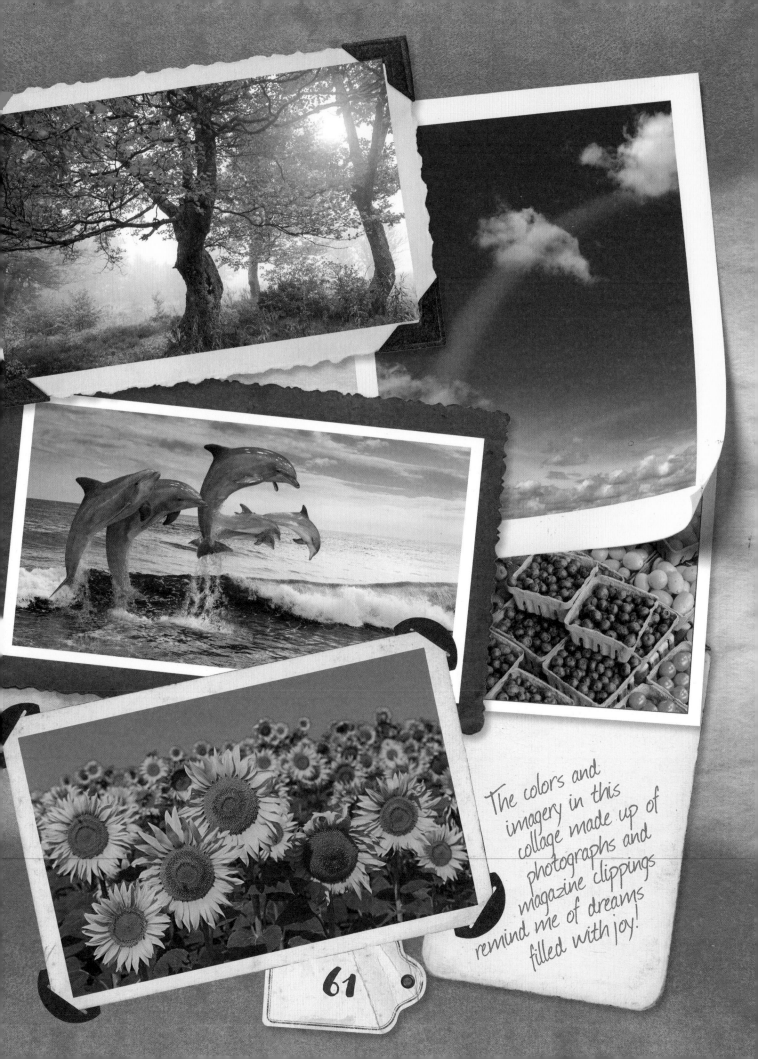

The colors and imagery in this collage made up of photographs and magazine clippings remind me of dreams filled with joy!

61

Happy Thoughts

Jottings and sketches from a dream journal often look confusing and difficult to interpret.

Tree, swirling branches... field of incredible flowers... dolphins—A UNICORN!

Before your dream fades, draw rough compositions that combine the main images. In my rough, a tree dominates the picture. I used the image of two entwined dolphins to form the curved shape of the tree trunk. The muted color of the background helps the white unicorn stand out despite its small stature.

Strong Design

My first composition lacked a strong design. In my second rough, the unicorn dominates the foreground and is the focal point of the image. Behind the unicorn lies a semicircle of huge flowers. The tree is still central to the composition, but the curving rainbow shape in the background unites all the imagery.

The tonal contrast of the black and gold background and the dark blue and golden yellow foreground makes the unicorn stand out more.

Graceful, stylized unicorn. . .

Colorful

Alternative Color Schemes

Although the black background used in the original rough (page 63) was very effective, I felt it deadened the joyousness of my dream. I experimented with different vibrant color schemes in order to create similar dramatic contrast.

(page 63)

Artist's tip: Scan the final rough, then try changing the color scheme by using a computer program. If you don't have access to a computer, trace out the image several times and roughly color in with felt-tip pens to see which colors work best.

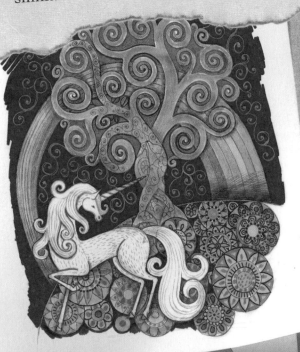

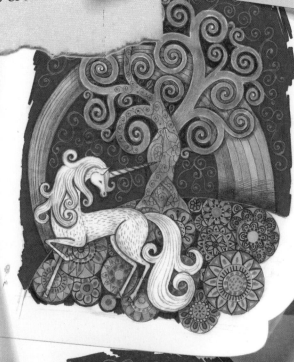

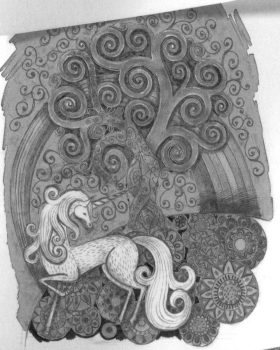

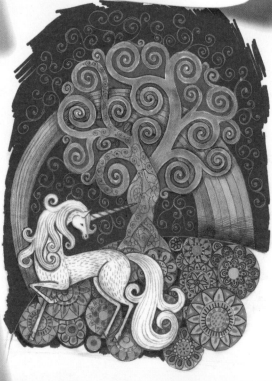

Drawing Out

Your finished design should be drawn up in a size that is comfortable for doodling. Use compasses to draw the circular flower designs or draw around a selection of coins and bottle tops of different sizes. Go over the finished drawing with a 0.1 mm black fineliner pen. When the ink is dry, erase any pencil lines.

Artist's tip: Use a piece of scrap paper to try out the colors. Some types of pen may smudge the black fineliner outlines; others may bleed when you use them to doodle on top of felt-tip coloring.

Blocking In

Start blocking in the main elements of your composition. Use fine felt-tip pens or fineliner pens to color the rainbow and the flower motifs. I used a limited palette of yellow, orange, and pale blue for the flowers. I also layered colors to create new shades.

Flower Power

Watercolor Wash

Use the sponging technique (pages 34–35). Paint art masking fluid over the tree, rainbow, unicorn, and flower pattern. Then add a dark purple watercolor wash to the background to create dramatic contrast. Once dry, rub off the rubber solution.

Dream Meanings

A dream containing a **rainbow** is very positive and a portent of joy and happiness. It suggests spiritual awakening: the rainbow acting like a bridge between your grounded self and a heightened state of self-awareness. Rainbows symbolize success, good fortune, hope, and fulfilled wishes.

Color in the tree with a golden brown felt-tip pen. Use a pale turquoise fineliner pen or a fine nibbed felt-tip pen to fill in the spaces between the branches.

Dream Meanings

Flowers symbolize beauty, joy, femininity, perfection, and spirituality. A dream in which you are surrounded by a carpet of flowers reflects your own enjoyment of life, naturalness, compassion, and gentleness.

Doodle Happiness

Now relax. Before you Zen Doodle the flowers, fill your mind with the happiness that you experienced during your dream. Use pale blue, yellow, and orange felt-tip pens and fineliner pens to add doodle patterns. Finish doodling the flowers with a 0.1 mm black fineliner pen.

Shading

Add subtle shading around the flowers to make them stand out. Use a ballpoint pen, pencil, crayons, or a fineliner pen to apply the cross-hatching technique (pages 22–23). Add more shading to the base of the rainbow and under the tree branches.

Unicorn

Gold, Silver...

Draw a thin, pale gray felt-tip pen line under the unicorn's mane, and beneath its front and rear legs to create shadow. Use silver and gold gel pens to doodle its mane, tail, body, and horn.

... and Bronze

Build up the color of the tree with a gold gel pen, then doodle curling patterns with a bronze gel pen. Zen doodle simple flower designs on the base of the rainbow. Finally, doodle swirling patterns in the background with a gold gel pen and then add silver gel pen dots.

Mounting and Framing

I recently bought this thin, dark frame at a local charity shop. It was far larger than my artwork but I used pale cream mounting cardboard as an inner frame to create a sense of space around my picture.

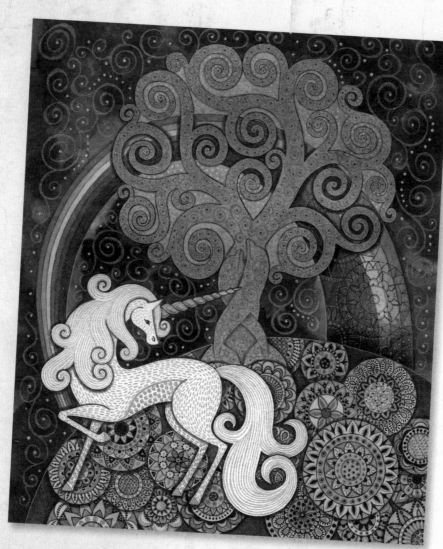

Happiness Dream

Dreams and Relationships

"I have spread my dreams beneath your feet;
Tread softly because you tread on my dreams."

WILLIAM BUTLER YEATS

Relationship Dreams

Unresolved Feelings

As relationships are an intrinsic part of our waking lives, our dreams, triggered by our affinity with others, can provide useful insights into unresolved feelings and issues. Relationship dreams tend to be difficult to interpret, often using symbolism that is complex and hard to decipher. Recurrent dreams are common and may reflect ongoing issues relating to other people, such as family or friends, that have been ignored and are causing stress.

"I dream of you to wake; would that I might Dream of you and not wake but slumber on."

CHRISTINA ROSSETTI

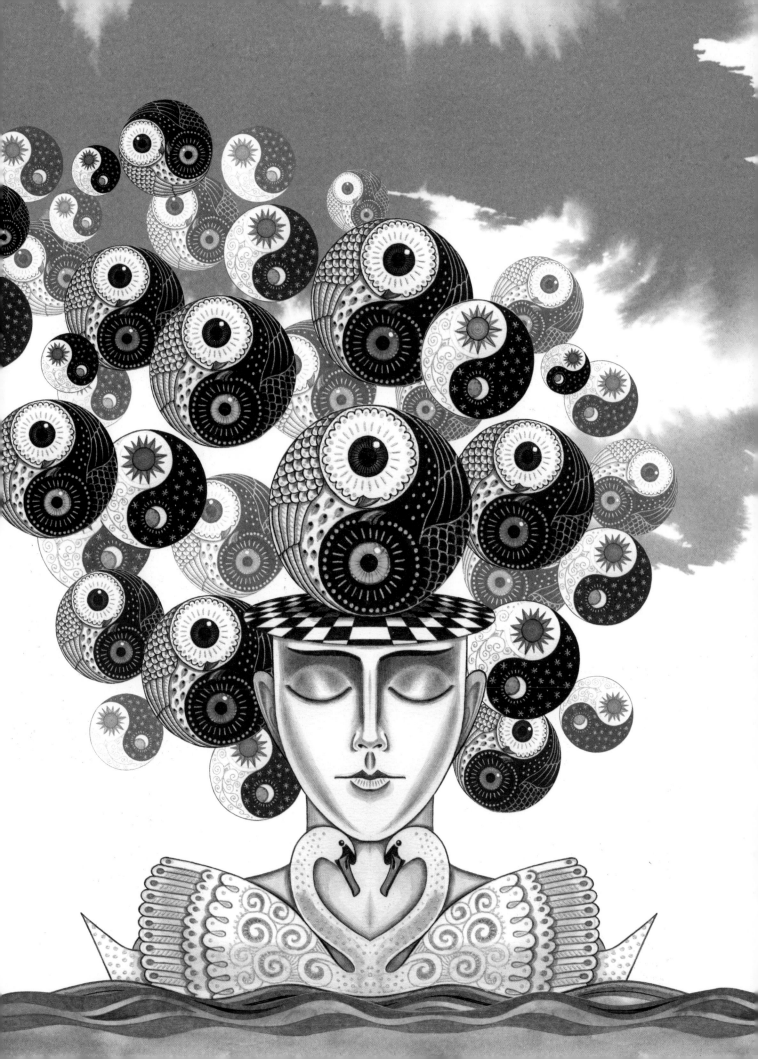

Relationship Dreams Collage

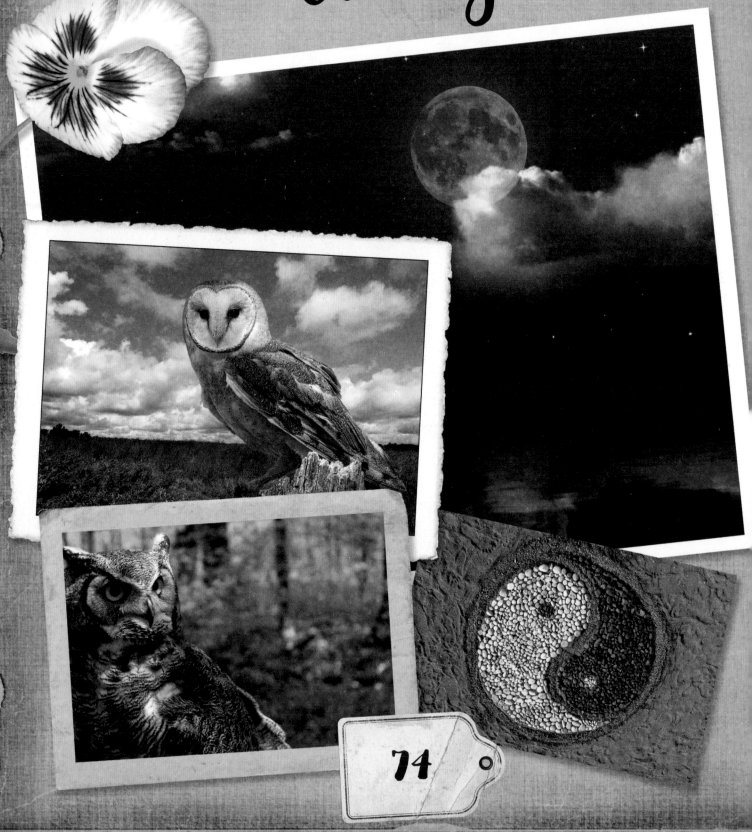

74

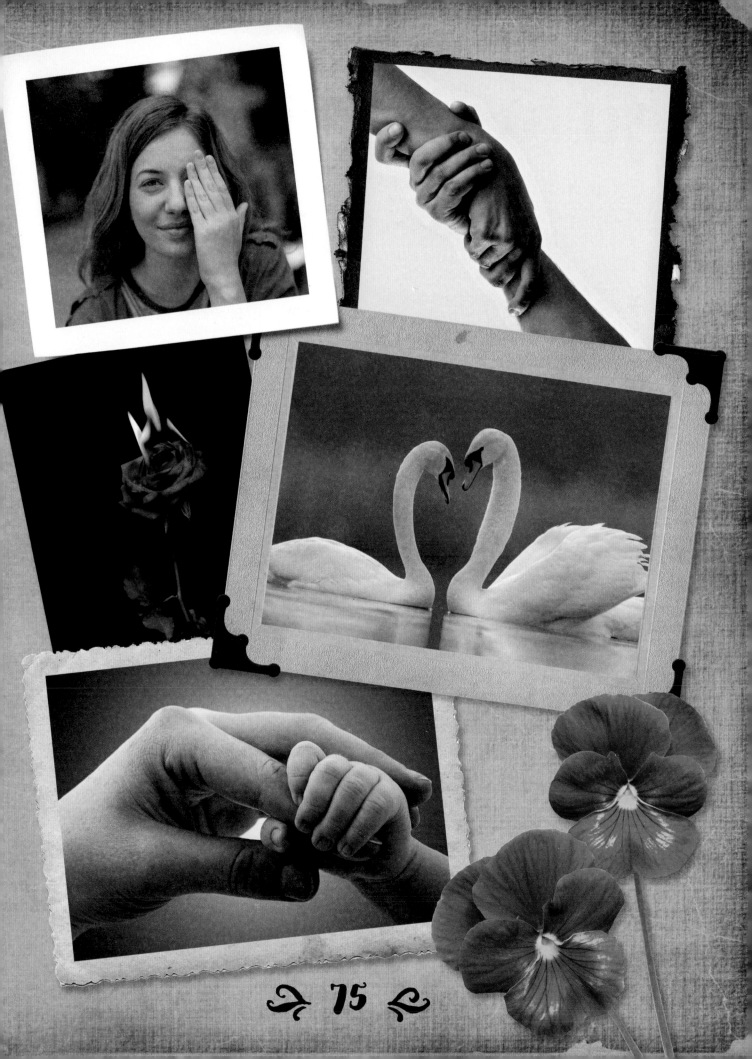

Yin and Yang

Calm and Relaxed

For a few days, I felt tense and had premonitions of impending catastrophe. Then one night I had a strange, mystical dream in which I felt blissfully calm and relaxed. The dream was full of disparate images, yet the yin and yang symbol resonated throughout. When I woke during the night I made these sketches in my dream journal (right and far right). The following day I resolved the family problems that had troubled me.

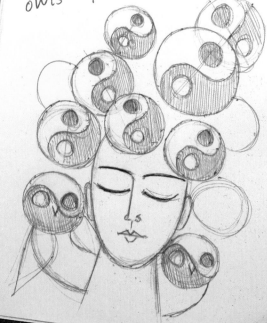

Dream journal...
Yin and yang symbols
owls - face - calm

Yin and yang - owls rough design

Two Owls

Use the contrasting images of a black owl and a white owl to form the teardrop shapes of the yin and yang symbol. Draw the owls with enlarged eyes and facial discs that fill the rounded ends, and adapt the wing feathers to fill the pointed ends.

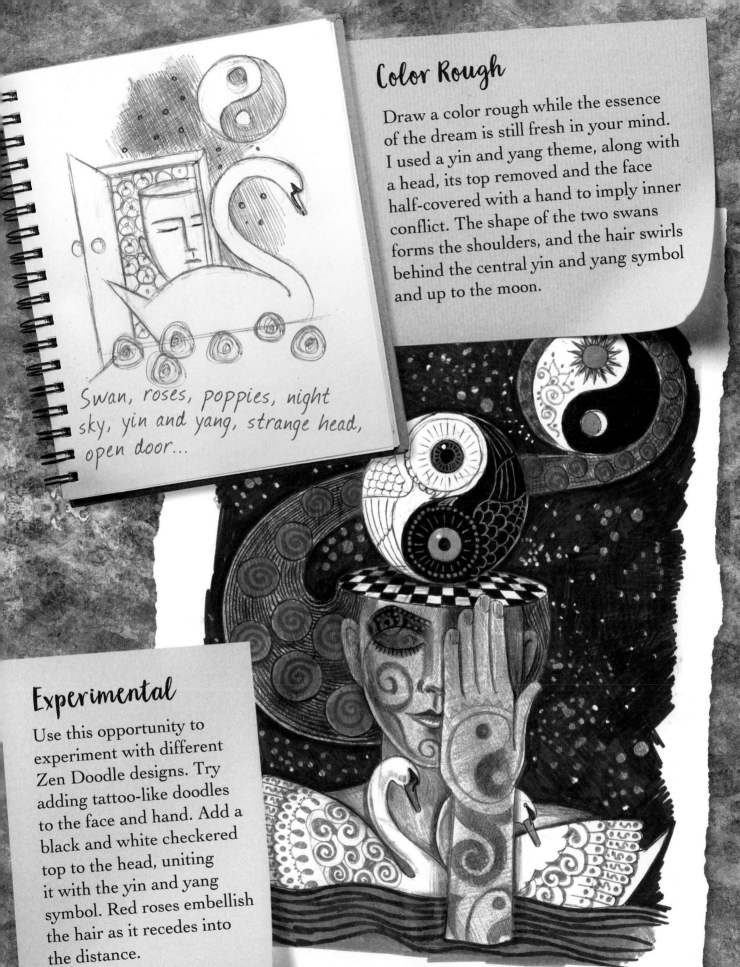

Swan, roses, poppies, night sky, yin and yang, strange head, open door...

Color Rough

Draw a color rough while the essence of the dream is still fresh in your mind. I used a yin and yang theme, along with a head, its top removed and the face half-covered with a hand to imply inner conflict. The shape of the two swans forms the shoulders, and the hair swirls behind the central yin and yang symbol and up to the moon.

Experimental

Use this opportunity to experiment with different Zen Doodle designs. Try adding tattoo-like doodles to the face and hand. Add a black and white checkered top to the head, uniting it with the yin and yang symbol. Red roses embellish the hair as it recedes into the distance.

Juxtapose

I decided to try adding another element to the composition and did a rough sketch of a yin and yang symbol formed from two owls inside an egg shell.

Dream Meanings

Since *owls* see in the dark, dreaming of one can imply that you have "seen" into your subconscious and gained insight into your hidden emotions. The owl symbolizes wisdom, but can also warn of the need to be cautious. Dreaming of a white owl, on the other hand, indicates optimism, the promise of happiness, and good fortune.

Yin yang owl in an egg

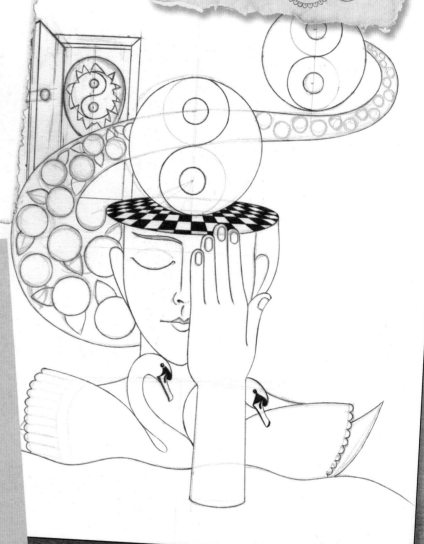

Final Composition

Redraw your final composition on thick paper to the size you feel comfortable working on. Incorporate any changes you wish to make to the design. I included the egg (above) by placing it inside the doorway behind the central head. Outline the main shapes with a 0.1 mm black fineliner pen.

Drama and Subtlety

Use the same pale blue to color both the figure and the swans to unite these shapes. Juxtapose the subtle blues with the dramatic blacks and whites used to color the hand and yin and yang symbols.

Color In

Use a black fineliner pen and a marker pen to block in solid black areas. Use watercolor paints (or felt-tip pens) to color in the hair, roses, and doorway. Use watercolor washes to paint in the face, swans, and the water in the foreground.

Dream Meanings

Yin and yang is a symbol of two halves that together complete each other. If your dream features yin and yang, it suggests you are nearing a state of inner stability. The symbol indicates that balance has been realized between the rational, masculine self and the intuitive, instinctive, feminine self.

Juxtapose (cont.)

Zen Doodle It!

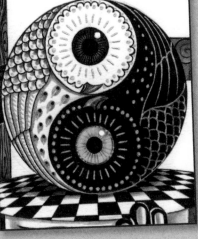

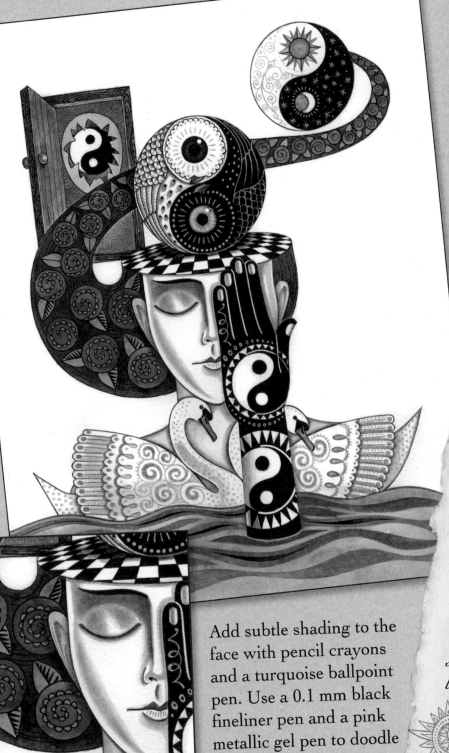

Use a 0.1 mm black fineliner pen, a pale gray felt-tip pen, and a silver gel pen to doodle the white owl. Use a silver gel pen to doodle the black owl. Add black ballpoint shading beneath the yin and yang symbol.

Add subtle shading to the face with pencil crayons and a turquoise ballpoint pen. Use a 0.1 mm black fineliner pen and a pink metallic gel pen to doodle the roses and hair.

Dream Meanings

A **white swan** symbolizes enlightenment, purity, innocence, and a desire for perfection. Dreaming of a swan swimming gracefully on water indicates good fortune, luck, and happiness in the future. Swans bond for many years, so dreaming about two swans may reflect the power of love in personal relationships.

Night Sky

Watercolor and Salt Technique

This simple technique produces exciting and mystical watercolor effects. It is an easy way of creating a night sky.

Artist's tip: To create different effects, try varying the size of the salt crystals and the color density.

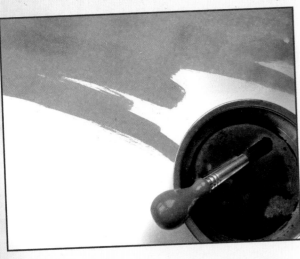

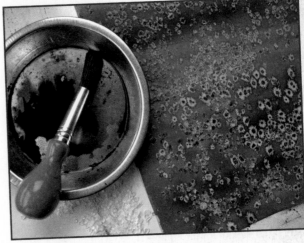

1 Paint a separate sheet of watercolor paper with a blue wash, then add bands of dark blue. Let the colors bleed.

2 Sprinkle rock salt over the watercolor wash while it is still wet but not too shiny.

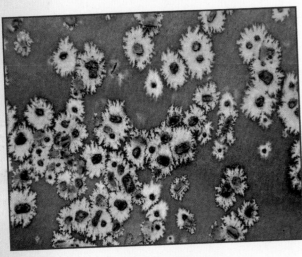

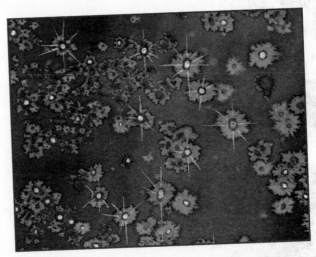

3 The salt crystals absorb the watercolor pigments, leaving pale flower-shaped markings.

4 When the paper is dry, brush off the salt crystals. Use silver and gold gel pens to Zen Doodle the night sky with magical stars.

Mystical, Magical

Add the Background

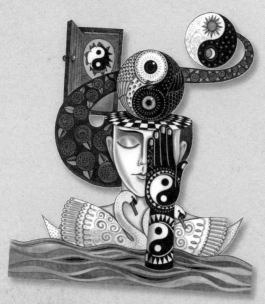

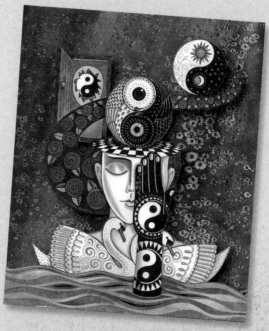

1 Carefully cut out the image with a fine white border around its edges.

2 Use adhesive spray mount to stick the image to the background.

Narrow Border—Pattern Deconstruction

Use thick black paper to make a thin frame for the artwork. Start by penciling in two parallel lines as guides.

Yin and yang motif

1 Use a gold gel pen and draw in a series of short, angled, parallel lines. Then draw a second set of lines (as shown).

2 Draw a series of curves along the top and bottom edges to create a plait pattern. Finish doodling it with rows of gold dots.

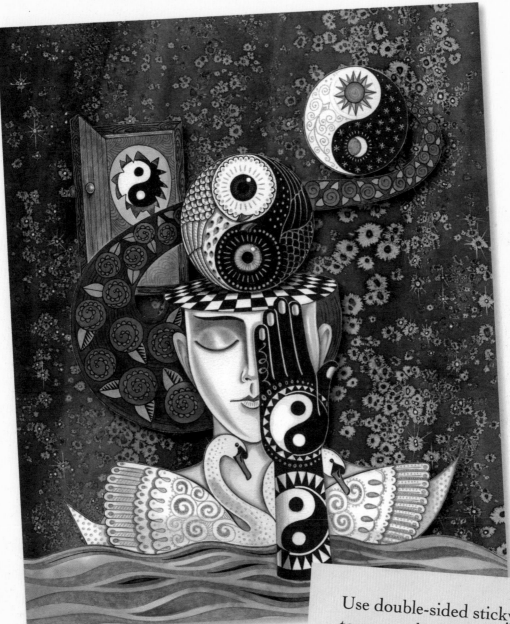

Mystical, Magical

Use double-sided sticky tape to mount the completed artwork onto a large, thick sheet of cream-colored cardboard. Stick the black and gold frame to the outer edge. Draw four black and gold yin and yang motifs to stick on each corner.

83

Dreams of Falling

"For often, when one is asleep, there is something in consciousness which declares that what then presents itself is but a dream."

ARISTOTLE

Falling Dreams

Hypnic Jerk

A very common type of falling dream, called a hypnic jerk, occurs just as a person is drifting off to sleep. They experience a sudden muscle spasm or jolt similar to falling which causes them to wake abruptly. About 70% of people regularly have this experience.

Frequent Dream

Another frequent dream involves the dreamer experiencing the sensation of falling. If the dreamer is fearful, it signifies anxiety or tension in their waking life. Alternatively, if the dreamer lets go and enjoys the sensation of falling, then the dream implies that they are ready to embrace change.

"We are such stuff as dreams are made on, and our little life is rounded with a sleep."

WILLIAM SHAKESPEARE

Falling Dreams Collage

Topsy Turvy

Internal or External

Dreams about falling often reflect a part of our waking life in which we feel out of control. It may be that we have neglected something, albeit internal or external, that needs addressing. Consider the manner in which the fall happens: for example, did you slip and lose your balance or your grip? Were you pushed or were you literally on the edge trying to hold on? It is relatively easy to interpret the metaphors; use them to help you analyze your dream.

Dream journal
Stairs, climbing, anxiety...

Falling, freedom, happiness...
billowing clouds, sunshine...

Precarious

I made this sketch the day after having a particularly vivid dream that involved a staircase tilting precariously downward and inward. I've had this dream before in different settings but it carries the same emotions each time I dream it. Although terrified, I managed to climb to the top, then started to fall.

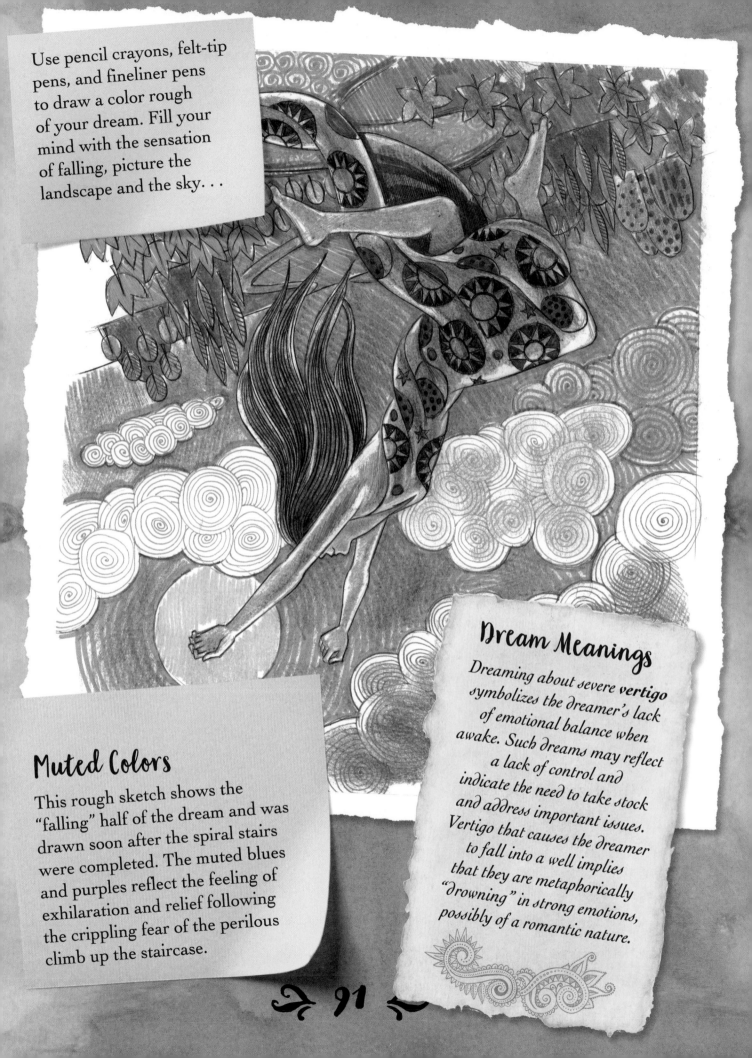

Use pencil crayons, felt-tip pens, and fineliner pens to draw a color rough of your dream. Fill your mind with the sensation of falling, picture the landscape and the sky. . .

Muted Colors

This rough sketch shows the "falling" half of the dream and was drawn soon after the spiral stairs were completed. The muted blues and purples reflect the feeling of exhilaration and relief following the crippling fear of the perilous climb up the staircase.

Dream Meanings

Dreaming about severe **vertigo** symbolizes the dreamer's lack of emotional balance when awake. Such dreams may reflect a lack of control and indicate the need to take stock and address important issues. Vertigo that causes the dreamer to fall into a well implies that they are metaphorically "drowning" in strong emotions, possibly of a romantic nature.

Extreme Perspective

Using Reference

Dreams are full of incredibly vivid images, but drawing them convincingly on paper can be difficult. To give your drawings credibility, use references when you work, either by getting inspiration directly from life, the things around you, or from photographs.

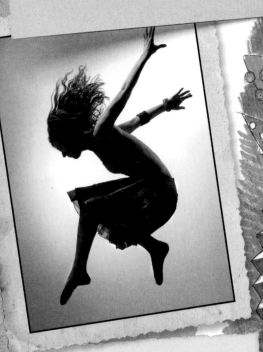

Combination

For my final composition, I combined a falling figure with the dramatic shape of a spiraling staircase behind. I used the photograph of a dancer (above) together with the image of the stairs (top right) as references.

Easy Steps...

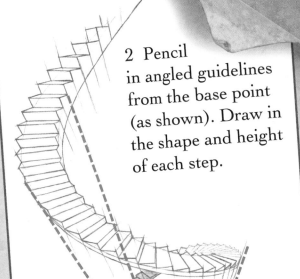

Direction of steps

1 Sketch in the curled shape of the stairs. Add depth, then draw angled lines to indicate the direction of the steps.

2 Pencil in angled guidelines from the base point (as shown). Draw in the shape and height of each step.

Base point

3 Go over the pencil lines with a fineliner pen. Erase the pencil sketch. Select a light source, then add shading using a soft pencil.

Dream Meanings

Dreaming about **climbing stairs** that are giving way may denote your disappointment over a setback and indicate the need to focus in order to achieve your goals. Feeling giddy while walking up stairs in a dream could be a warning that you have inner doubts about the path you have chosen.

Head Over Heels

Right Size

Use a pencil to draw out your final composition onto a large sheet of thick cartridge paper. Make sure the design is fairly large. My finished artwork was approximately 9½" (24 cm) wide by 12¾" (32 cm) high. This was an ideal size for using the indenting technique (pages 96–97) for the river, sky, clouds, and sun.

Artist's tip: To create a sense of depth, use soft, muted colors for the landscape with strong contrasting colors for the figure and staircase.

Leaf-Shaped Trees

Ink in the pencil lines using a 0.1 mm black fineliner pen for the stairs and figure. Use a pale green ballpoint or fineliner pen to ink in the landscape. To add to the dreamlike feel of the design, draw all the trees in the background so they are leaf-shaped.

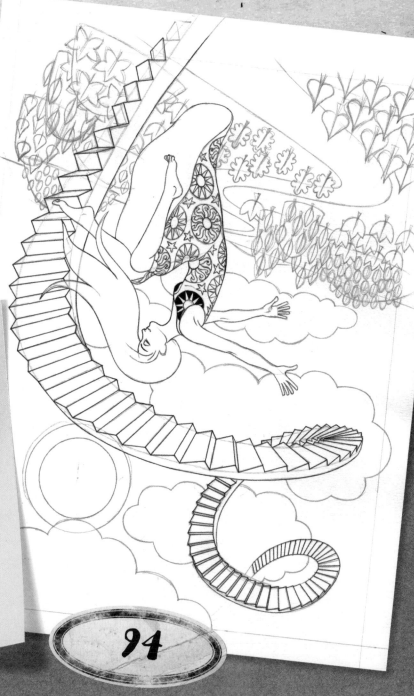

Blocking In

Erase the pencil lines. Use pale blue, purple, gray, and orange fineliner pens and felt-tips to block in the landscape. Refer to the sun as the light source and use a black marker pen to block in the deepest shadows. Use a 0.1 mm black fineliner pen for hatching the mid-tones. Color in the figure using blue and purple watercolor washes.

Dream Meanings

If **leaves** feature in your dream, it is a very positive sign, as they are associated with either personal growth or time. While oak leaves in particular represent caring and protection, dreaming of many leaves infers a multiplicity of creative ideas and thoughts.

Turn the picture upside down to make it easier to doodle. Use a bronze gel pen together with blue and purple fineliner pens to Zen Doodle the leaves. Use a black fineliner pen on the hair and to doodle bold patterns on the figure's clothes.

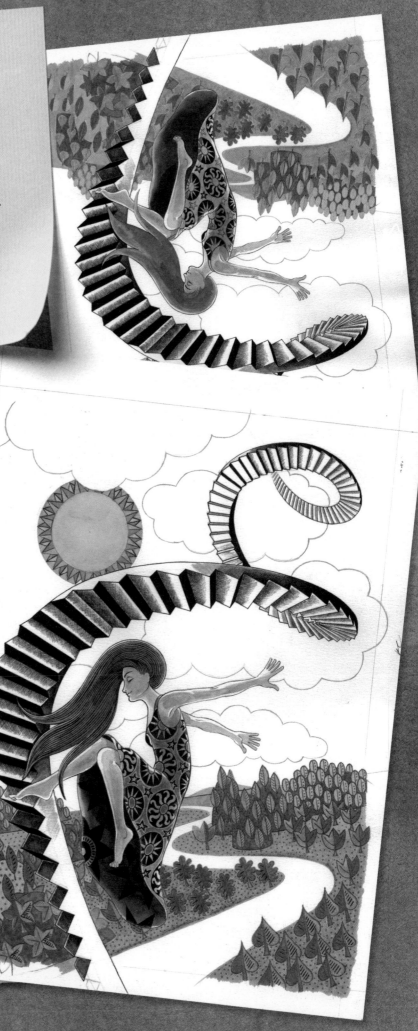

Indenting Technique

Simple and Effective

Indenting is fun. It is a simple and very effective drawing technique. Designs are indented or incised on paper. When colored pencil crayon shading is applied, the indented lines are revealed, creating stunning artwork of white or pale colored lines.

Artist's tip: This technique works best if you use smooth rather than rough textured paper. It also helps to place the artwork on a hard surface when indenting.

Experiment first on scrap paper...

Experimentation

Try indenting a spare scrap of the same paper as your artwork. Experiment by using different tools as styluses and a variety of colored pencil crayons for the background color.

1 Use an empty ballpoint pen as a stylus. Press hard and indent swirling doodles into the clouds. To add contrast, block in the sky with a pale blue felt-tip pen, then indent with Zen Doodle patterns.

2 Now for the exciting part. Shade over the indented clouds with a pale blue pencil crayon and watch the patterns magically appear! Next, shade over the sky area (leave a white edge around the clouds).

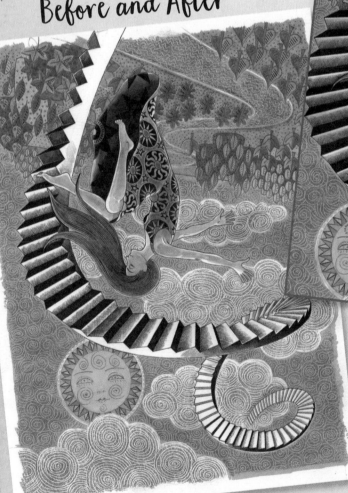

3 Block in the river with a pale blue felt-tip pen. Indent with wave-shaped doodles, then shade over with pale blue and dark green pencil crayons.

Dream Meanings

Clouds that feature in dreams can have divergent interpretations depending on their context. In some instances, they can imply inspiring emotions, but they may also warn of the concealment of potential problems. White, rounded clouds symbolize pleasure, positive energy, and may also indicate tranquility and peace of mind.

Before and After

Adding Depth

To add depth to the composition, add pencil shading to the figure and stairs. This will make them stand out from the pale background.

and After

Before...

Weight and Contrast

The finished artwork is generally pale, with dark shades restricted to the stairs and figure. To add weight and a sense of gravitas, I used a wide, dark frame for contrast.

Black Indented Frame

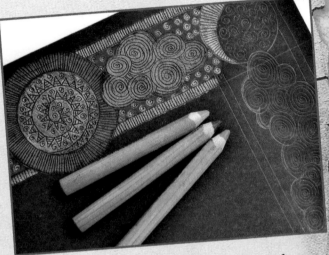

1 Measure the finished artwork. Allow for a narrow white border around it. Mark out a frame—approximately 2¼" (6 cm) wide—onto a thick sheet of black paper. Lightly pencil in your design, then indent with an empty ballpoint pen.

2 Erase the pencil lines. Lightly color in the doodled indentations with gold, pale blue, dark blue, orange, and purple pencil crayons.

3 Carefully cut out the finished dream artwork. Use double-sided tape to stick it down onto a sheet of thick white cartridge paper. Measure a narrow border (¼") around the artwork, then cut around its outer edge. Finally, use double-sided tape to stick the artwork, complete with white border, inside the black frame.

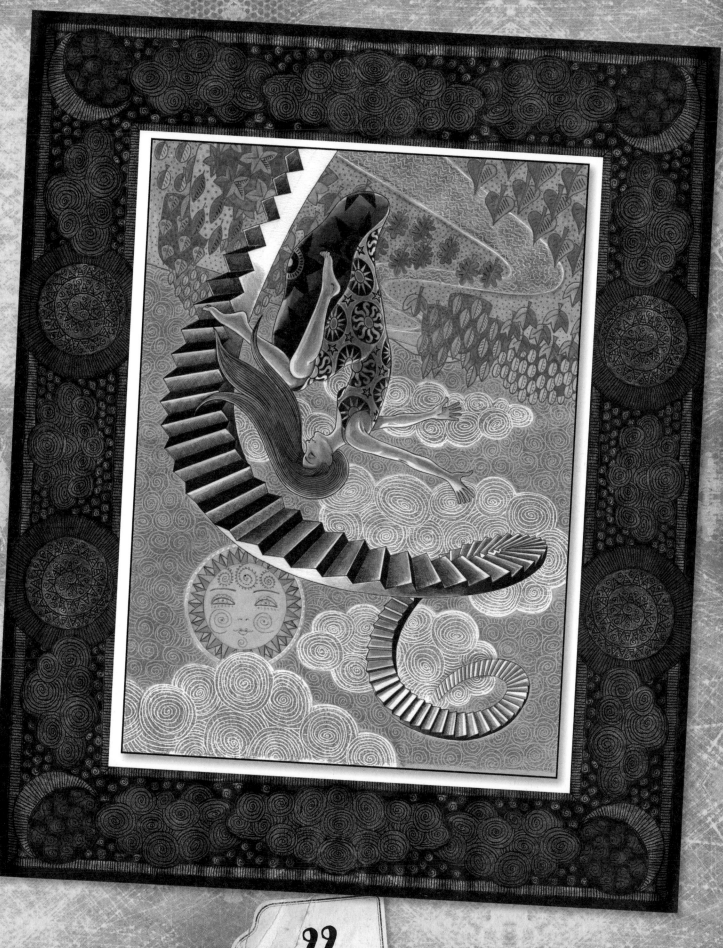

99

Dreams of Chasing

"Those who have compared our life to a dream were right...We sleeping wake, and waking sleep."

MICHEL DE MONTAIGNE

Chasing Dreams

Strong Feelings

Dreams about chasing after something or of being chased are common. In general, dreams of being chased reflect the unconscious mind telling the dreamer they are avoiding something, whether a person, a problem, or their own emotions. The latter interpretation is that the pursuer in the dream portrays an emotional aspect of the dreamer. For example, strong feelings of a hidden love for someone could be presented in the form of a shadowy figure. . .

If, on the other hand, it is you who is doing the chasing, it is important to understand what it is you are running after. The dream could be indicative of the need to keep up the momentum of your efforts in your waking life in order to achieve personal goals.

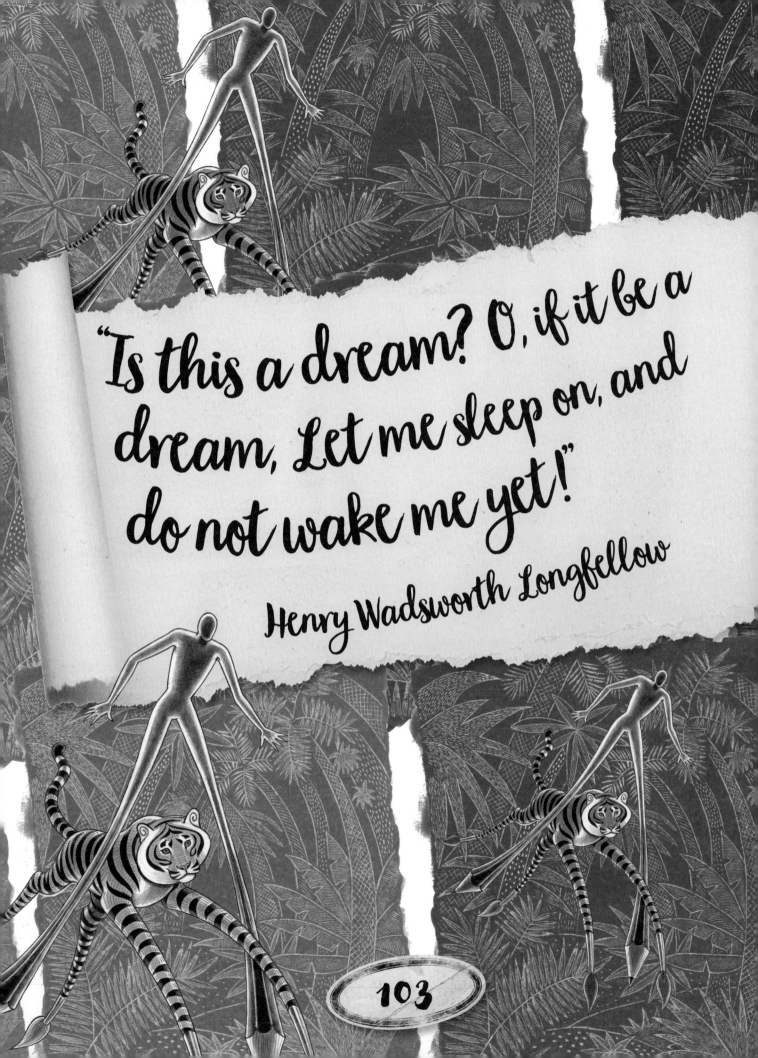

"Is this a dream? O, if it be a dream, Let me sleep on, and do not wake me yet!"

Henry Wadsworth Longfellow

Chasing Dreams Collage

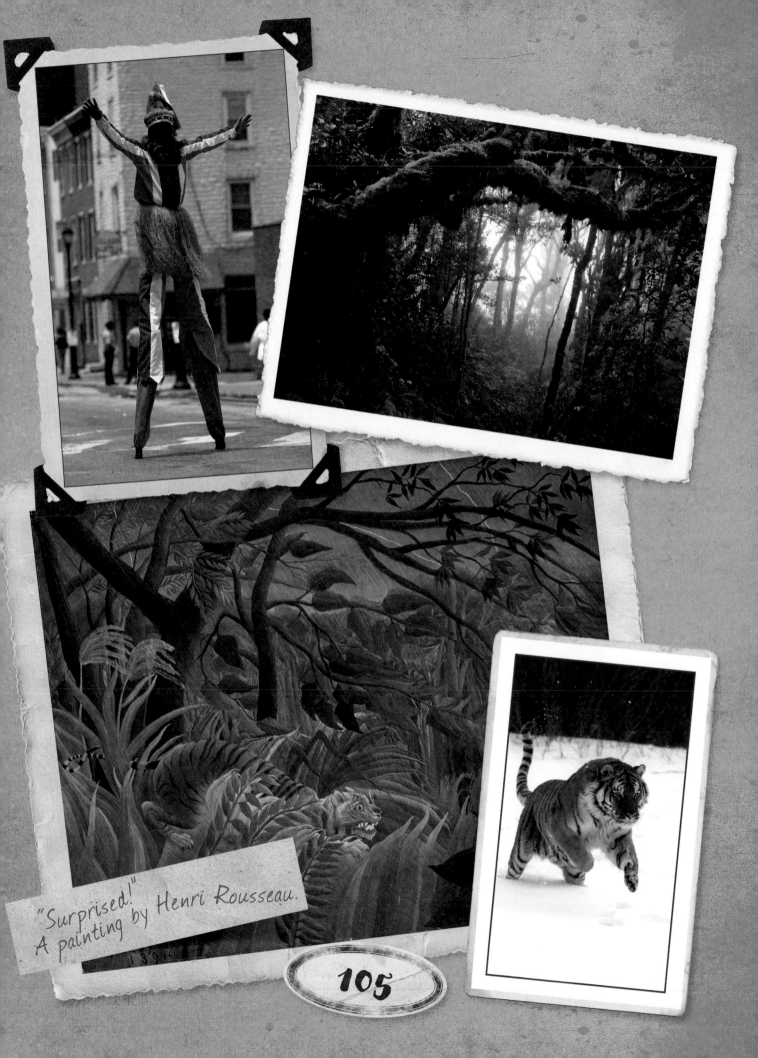

"Surprised!"
A painting by Henri Rousseau.

Fantasy Forest

Exotic Colors

As a child, I frequently dreamt of being chased. These dreams had ceased for many years, then the other night I had an exceptionally vivid dream in which a shadowy figure and a beautiful tiger were chasing me through a fantasy rainforest. Although both had extraordinarily long legs and could run very fast, I managed to stay a safe distance ahead and felt excited rather than frightened. The forest looked like one of Henri Rousseau's magical jungle paintings, filled with brightly colored, exotic plants.

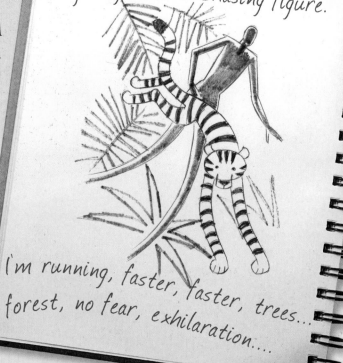

Dream journal...
Tiger, graceful! Chasing figure.

I'm running, faster, faster, trees... forest, no fear, exhilaration....

Color Sketch

The dream stayed with me for several days and I made this color sketch before the vivid images faded.

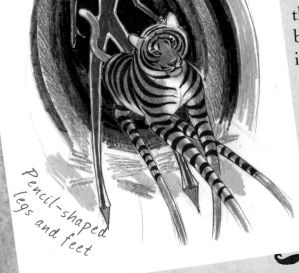

Pencil-shaped legs and feet

Dream Meanings

If your dream features a **tropical rainforest**, it indicates spiritual enlightenment; that you have mentally relaxed and are in touch with your inner being. **Vivid green leaves** may represent happiness derived from loving relationships or pleasure gained from friendships.

Finished Color Rough

I usually draw several roughs and then either select the strongest or adapt and combine several to produce the finished design. However, in this case, I felt the initial rough aptly captured the essence of the dream. I used exaggerated perspective to highlight the tremendous height of the trees. To convey the mystical atmosphere of Rousseau's forest, I used his color palette, too.

The shadowy figure's legs turn into pencils. I continued the surreal theme by adapting the tiger's legs to become paint brushes.

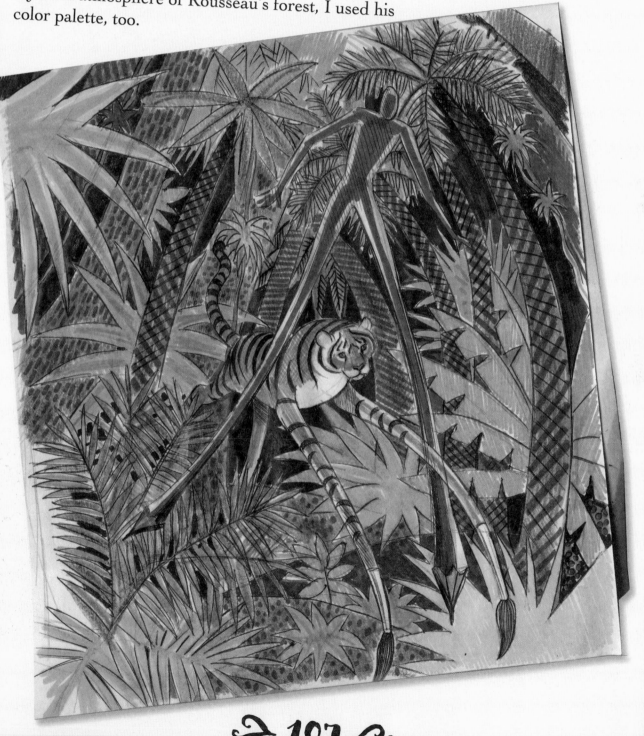

Crayon Etching

Exciting Technique

This exciting technique uses the resistance of wax crayons with water-based paint to create a surface that doodles can be etched into.

Artist's tip: Tape your finished rough to a window pane, place a sheet of smooth cartridge paper on top, and tape in place. Use the light shining through the window to trace out the background design.

1 Use a yellow pencil crayon to trace out the rainforest backgound (see *Artist's tip* above). Color in with wax crayons.

2 Pale, colored crayons work best. Press down hard as you work and try not to leave any blank spaces.

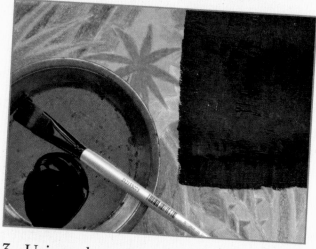

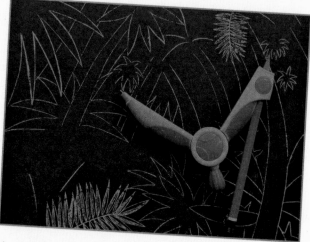

3 Using a large brush, paint black, liquid gouache (tempera) over the surface of the wax crayoning. Leave to dry overnight.

4 Lightly indent your drawing onto the painted surface by retracing the design. Use a stylus (step 5, opposite) to draw the outline of the rainforest.

Different Lines

5 Before you start finalizing your artwork, prepare a scrap piece of cartridge paper with crayon and tempera. When dry, experiment by using a selection of styluses, such as knitting needles, an opened paper clip, or a compass tip to etch the surface. Choose the methods that work best. I used the point of a pair of compasses as my main stylus and a toothpick for etching finer lines.

Tempera

Tempera dries to a thick matte surface that may flake when etched. If a large area flakes off, apply a fresh layer of tempera and leave to dry. Note: it may be more difficult to etch the second time around.

Rest your drawing hand on scrap paper to prevent it from scratching the delicate tempera surface.

Crayon Etching (cont.)

Simple Doodles

Etch the tree trunks with simple doodled patterns of stripes, dots, dashes, and checks. Etch the doodles closer together to reveal more color. Leave a thin, black border around the different shapes to help make them stand out.

Keep Clean

Keep your artwork clean by regularly blowing away the paint dust as you etch. Add contrast to the design by leaving the background between the tree trunks black.

Running Figures

Separate Artwork

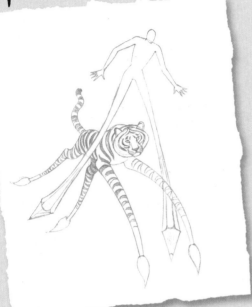

1 Trace out the tiger and the figure onto a separate sheet of cartridge paper.

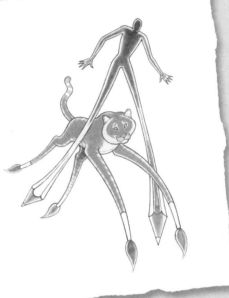

2 Use a 0.1 mm black fineliner pen to draw in the outlines. Block in the main colors.

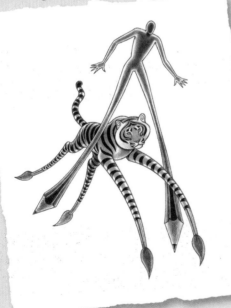

3 Add detail. Use pencil and fineliner shading to build up the tone to produce a 3D effect.

Dream Meanings

Tigers symbolize strength, assertiveness, and bravery. Dreaming of being chased by a tiger may be a warning that, no matter how hard you run, you are unable to elude the problems in your waking life. Alternatively, it can represent overpowering emotions and passions that you are "running away" from while awake.

On the Edge

Illusion of 3D

The simplest method of attaching the figures to the background is to carefully cut the shape out, spray the back with aerosol adhesive, and stick it in place. Or you can create a 3D illusion by first mounting the figures on thin cardboard, then cutting out tiny squares of thick cardboard, and using double-sided tape to stick them to the reverse side. Place a square at the end of each leg and on the body shapes. Turn over and stick the squares to the background.

Frame Design

This crayon etching technique is a variation on that described on page 108.

1 Pencil in five parallel guidelines. Draw in a series of leaf shapes, using the three central lines as your guide.

2 Draw a thin leaf shape in the middle of each and add small triangles (as above). Use a fineliner pen to ink in.

3 Color in the white spaces with wax crayon. Paint over the entire frame design with black tempura. Leave to dry overnight.

4 Use a stylus (see page 109) to doodle simple patterns into the paint, revealing the wax crayon beneath.

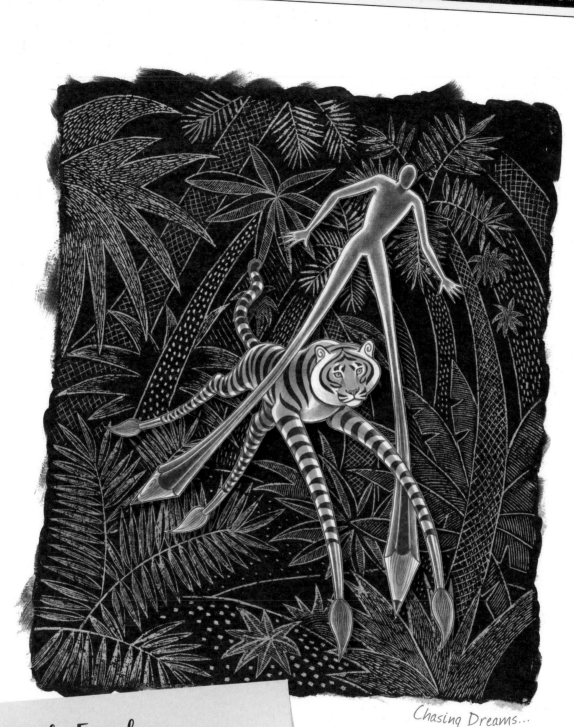

Chasing Dreams...

Painterly Finish

Leaving the painterly edges around the artwork adds a fresh, lively quality to the image. Mount your etching on a sheet of cream cardboard, then use double-sided tape to stick the black frame in place.

World of Dreams

Journey of the Subconscious

"Our truest life
is when we are
in dreams awake."

Henry David Thoreau

Vivid Sequence

Occasionally, during a particularly vivid dream, I briefly wake up and quickly jot down my impressions before I drift back to sleep to pick up the threads of the dream as I go. . .This sequence can happen several times and leaves me feeling as if the entire night was filled with a single continuous dream that haunts me for several days.

Last night's journey of the subconscious was one such dream!

Dream journal
I am climbing stairs trying to reach the moon and stars....

Freedom! Excitement!

Banks of swirling cotton wool clouds, velvet night sky

Lush green leaves, that turn into fish that glitter in the moonlight.

Landscape of low, rounded hills covered in psychedelic flowers...

Consistent Theme

A consistent theme throughout my dreams was a staircase rising toward the sky, which I gradually ascended. The fantastical world of my dreams was at one point filled with fairy tale castles and then with flying turtles. On occasion, apples grew on tree trunks while butterflies had catlike bodies. Throughout the dream the sun and moon smiled benignly down from the night sky above.

Dream Meanings

If your dream features a vivid **fantasy world**, it may indicate a hidden need for escapism; that you want more magical, exciting experiences in your waking life. On the other hand, the dream could imply your need to think "outside the box" and explore your creative imagination.

Draw a rough composition that includes the most powerful images from your night's dreams.

Color Schemes

Different Combinations

Draw out the finished composition to the size you intend to work. Choose a color scheme and roughly color in the drawing. If you have access to a computer, scan the image and use a program to try out different colors. If not, make tracings of the design and have fun experimenting with different color combinations by roughly coloring in each one.

Select the most effective color scheme!

Drawing Out

Trace the finished composition onto thick cartridge paper. Start adding watercolor washes to the background. First paint each main area of the design with clean water, then add watercolor paint. Let the colors bleed and merge to create interesting watermarks and textures.

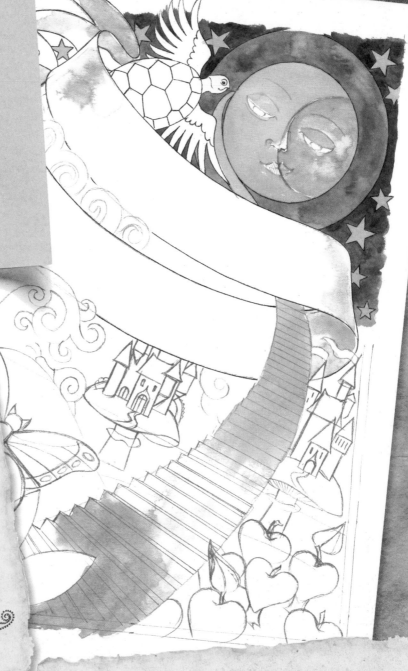

Dream Meanings

To dream that it is **night time** could imply that there are things in your waking life hindering you from achieving your goals. However, if there is enough light to see in your dream, it implies that you have illuminated something that was once unclear, and are now heading in the right direction.

Artist's tip: If the cartridge paper starts to buckle when dry, place on a flat surface, lay a sheet of cardboard on top, weigh it down, and leave overnight to flatten.

Dream Meanings

If **apples** feature in your dream, it is a sign that your life is full of love, happiness, and contentment. Combine the apples with heart shapes and the symbolism becomes very powerful. Dreaming of hearts not only signifies love, it also represents courage, truth, and romantic passion.

Building Up

Different Combinations

Finish adding washes to the background (right). Now relax and recall the magical, surreal images from your dream. Fill your mind with the sense of excitement and liberation you felt when climbing the staircase. Start Zen Doodling (below) and enjoy the daydream.

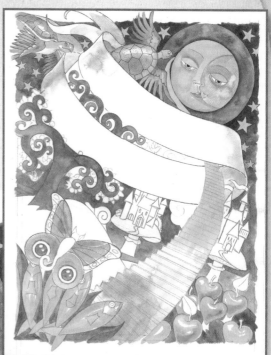

Dream Meanings

Dreaming of colorful *fish* swimming about can indicate awareness of your subconscious mind. However, if the fish in your dream are in an odd place, it could imply that a particularly uncomfortable situation in your waking life is making you feel metaphorically "like a fish out of water."

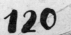

Sun and Moon

Use a 0.1 mm black fineliner pen to doodle patterns around the sun and moon. Add pencil shading to the faces, then start to doodle patterns using gold and bronze gel pens.

Funky Fish

Use pencil crayons to add shading to the fish, then doodle their bodies with a fish scale pattern using fineliner pens. Add final detail with a 0.1 mm black fineliner pen.

Apple Trees

Add pencil shading to the stairs. Use pencil crayons to add shading to the heart-shaped apples. Doodle patterns using fineliner pens. Use a 0.1 mm black fineliner pen to outline shapes and to add detail.

Gilded Frame

Ornate and Elaborate

I used this photograph (right) as inspiration to create a border for the artwork, which echoes an ornate, elaborate, traditional gilt picture frame. Start by making a rough sketch of the design. Draw the outline of the frame, then add the main shapes of the curved decorations.

Dream Meanings

A **frame** contains a picture and creates a rigid border around it. Similarly, dreaming of one can imply a limited, restrictive way of thinking, or that you are stifling your creativity. If the frame in your dream is ornate, it could indicate that you are upset and anxious.

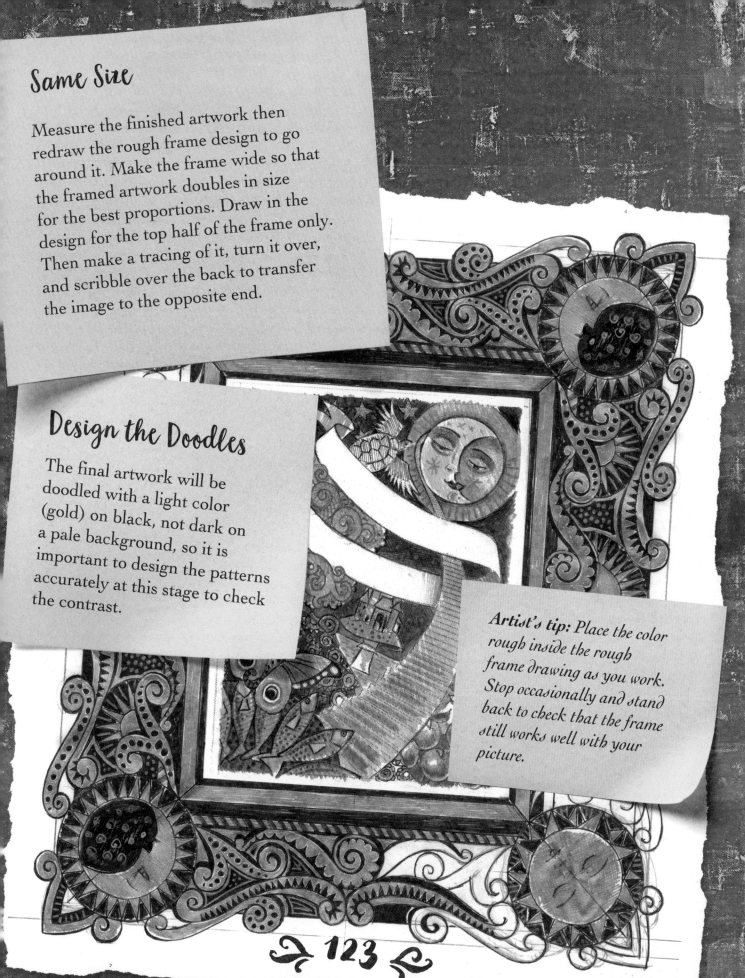

Same Size

Measure the finished artwork then redraw the rough frame design to go around it. Make the frame wide so that the framed artwork doubles in size for the best proportions. Draw in the design for the top half of the frame only. Then make a tracing of it, turn it over, and scribble over the back to transfer the image to the opposite end.

Design the Doodles

The final artwork will be doodled with a light color (gold) on black, not dark on a pale background, so it is important to design the patterns accurately at this stage to check the contrast.

Artist's tip: Place the color rough inside the rough frame drawing as you work. Stop occasionally and stand back to check that the frame still works well with your picture.

Embellishing

Light and Dark

Use thin black cardboard or thick black paper for the frame. Trace out the finished design. The shiny pencil lines will catch the light and show up against the dark background.

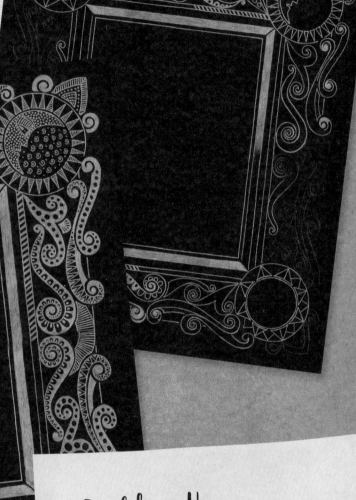

Building Up

Use a gold gel pen to outline the frame design (above). Keep the doodled patterns simple and block in main areas of gold (above left). Finish doodling the gold. Use a bronze gel pen to doodle the background to add richness and final details (left).

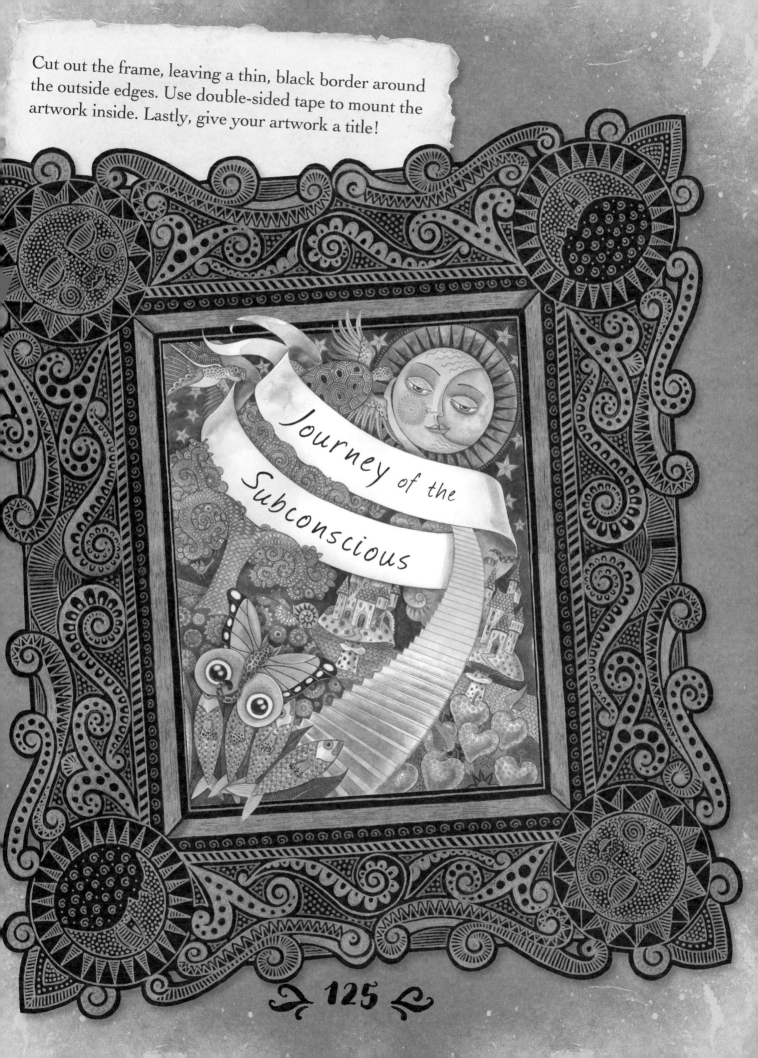

Cut out the frame, leaving a thin, black border around the outside edges. Use double-sided tape to mount the artwork inside. Lastly, give your artwork a title!

Journey of the Subconscious

Glossary

3D having, or seeming to have, the three dimensions of depth, width, and height.

Analogous colors harmonious colors that lie next to each other on the color wheel (page 17).

Art masking fluid a rubbery solution used to block out areas of paper so watercolors are not absorbed.

Collage artwork made by gluing things to a surface.

Color rough unfinished sketch, drawn quickly and simply colored.

Color scheme the selection of colors used in a design.

Color temperature the coolness or warmth of a color (blue-green is coldest and red-orange is warmest).

Complementary colors lie opposite each other on the color wheel (page 17). Used side by side, they convey energy and excitement.

Composition the arrangement of the main parts of a design so as to form a unified whole.

Conscious being aware of an external object or something within oneself.

Crayon etching covering a surface with wax crayon, then etching lines into it using a stylus.

Cross-hatching a shading technique using two or more sets of intersecting parallel lines.

Deconstruct break down a pattern into simple components.

Design a graphic representation, usually a drawing or a sketch.

Dreamcatcher a small, willow hoop containing a woven "web," believed to give its owner good dreams.

Enlightenment achieving insight or knowledge.

Euphoria a feeling of intense happiness and well-being.

Focal point the area or object in a design that attracts a viewer's eye.

Hatching a shading technique using a series of parallel lines.

Indenting the use of a blunt instrument to indent lines on paper, which show as white lines once crayoned.

Light source the direction from which light originates.

Limited palette a restricted number of colors used in artwork.

Metaphysical art a style of painting that prospered mainly in Italy between 1911 and 1920.

Mixed media a technique using two or more artistic media.

Motif a strong and possibly recurring shape or image in a design.

Primary colors the three colors (red, yellow, and blue) from which all other colors can be mixed.

Relief printing the technique of cutting, indenting, or etching a printing block so that the remaining surface design only is printed.

Resist technique the use of art masking fluids to prevent water-based paints from flooding specific areas.

Secondary colors colors that are made by mixing two of the three primary colors.

Shading the means an artist uses to represent gradations of tone.

Stylus a small tool for marking or engraving.

Subconscious the part of the mind that a person is not fully aware of but which influences their actions and feelings.

Surrealism an artistic movement of the early twentieth century that aimed to use dreams and visions to unlock the imagination.

Symbolism the depiction of something using symbols or giving symbolic meaning to something.

Symbolist movement an artistic style that developed in the late nineteenth century. It used symbols to convey ideas and forms, shapes, lines, and colors to emphasize meaning.

Tertiary colors the colors formed by mixing a primary and a secondary color together.

Thumbnail sketch a small sketch that is quickly executed.

Tonal contrast the difference between the lightest and darkest parts of an image.

Watercolor wash a wash of diluted watercolor painted across paper.

Wax resist the use of wax marks to prevent water-based paint from reaching an area.

Index

3D 22-23, 37, 49, 111-112, 126

A
analogous colors 17, 126

B
background 9, 21, 23, 34-35, 51, 62-64, 66, 68, 82, 94, 96-97, 108, 110, 112, 119-120, 123-124
bleed 34, 65, 81, 119
blocking in 12-13, 38, 48, 51, 65, 79, 95-97, 111, 124
border 37, 82, 98, 110, 122, 125

C
collage 44-45, 60-61, 74-75, 88-89, 104-105, 126
color rough 46-48, 77, 91, 107, 123, 126
color scheme 16-17, 20, 64, 118, 126
compasses 19, 65, 109
complementary colors 17, 126
composition 34, 62-63, 65, 78, 92, 94, 97, 118, 126
cross-hatching 22-23, 51, 67, 126

E
emotions 9-10, 14, 25, 28, 33, 42, 56-59, 78, 90-91, 97, 102, 111

F
frame 48, 53-55, 69, 82-83, 98, 112-113, 122 125

G
gilding 54, 122

H
hatching 22-23, 36, 51, 95, 126

I
indent/indenting 8, 53, 94, 96-98, 108, 126 127

L
light source 22-23, 35, 49, 93, 95, 126
limited palette 20, 65, 127

M
masking fluid 34-35, 66, 126-127
metaphor 9, 50, 90-91, 120

P
perspective 92-93, 107
primary colors 16, 127
print 53-54, 127

R
relief printing 8, 53, 127
resist 34-35, 66, 127
rough 18, 32, 48, 50, 62-64, 76, 78, 91, 107 108, 118, 122-123

S
secondary colors 16, 127
shading 12, 22-23, 35-37, 48, 51, 65, 67-68, 80, 93, 95-98, 111, 121, 126-127
sketching 9, 13, 18, 25, 32-34, 46, 62, 76, 78, 90-91, 93, 106, 122, 126-127
stylus 96, 108-109, 112, 126-127
subconscious 10, 59, 116, 120, 127
Surrealism 10-11, 32, 107, 120, 127
symbolism 9-11, 15, 37-38, 50, 54, 66-68, 72, 76-80, 91, 97, 111, 119, 127

T
tertiary colors 16, 127
tonal contrast 48, 63, 127
tracing 34, 38, 50, 53, 64, 108, 111, 118-119, 123-124

W
watercolor 12-13, 34, 38, 51, 79, 81, 119, 126-127
watercolor wash 8, 13, 35, 38, 51, 66, 79, 81, 94, 119, 127
wax resist 108